Grand Teton
impressions

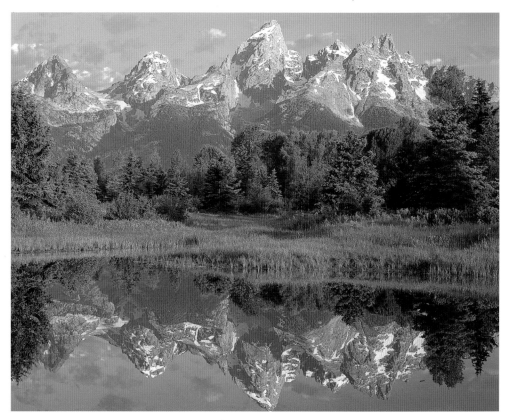

photography by
Henry H. Holdsworth and Fred Pflughoft

FARCOUNTRY
PRESS

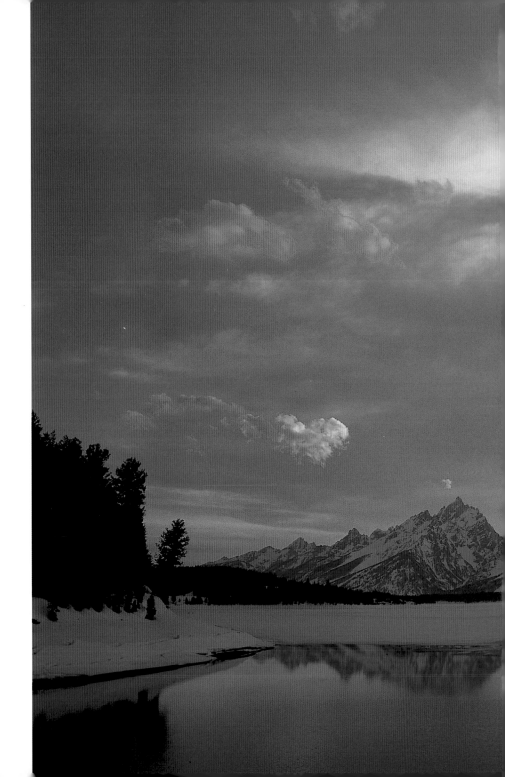

Right: The Tetons rise above Jackson Lake.
FRED PFLUGHOFT

Front cover: On the former Moulton Ranch.
HENRY H. HOLDSWORTH

Back cover: Tetons at sunrise. FRED PFLUGHOFT

Title page: Sunrise view of the Tetons from
Schwabacher's Landing on the Snake River.
HENRY H. HOLDSWORTH

ISBN: 1-56037-208-7
Photographs © by individual photographers as credited
© 2002 Farcountry Press

Created, produced, and designed in the United States.
Printed in Korea

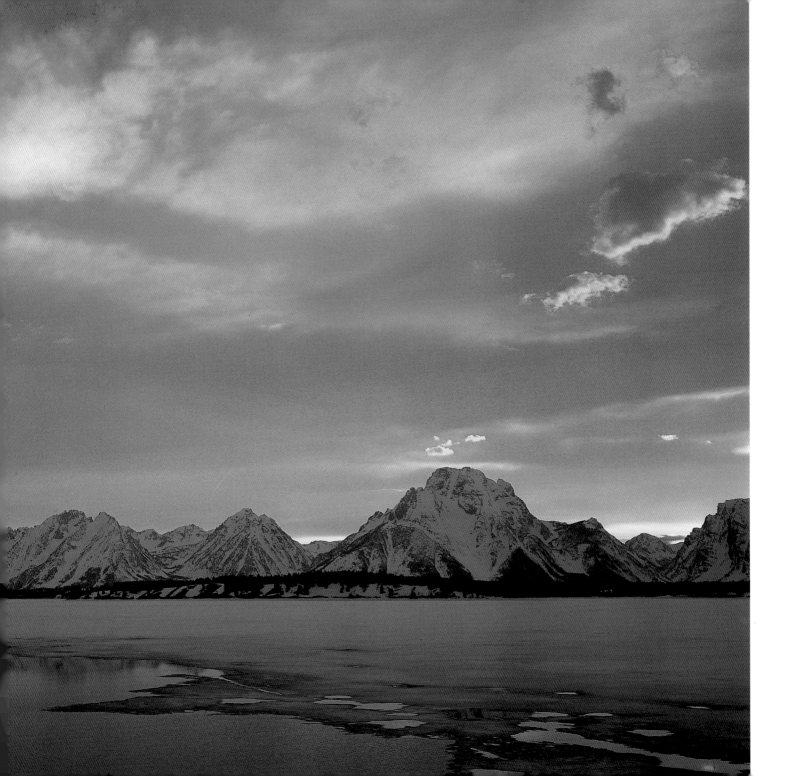

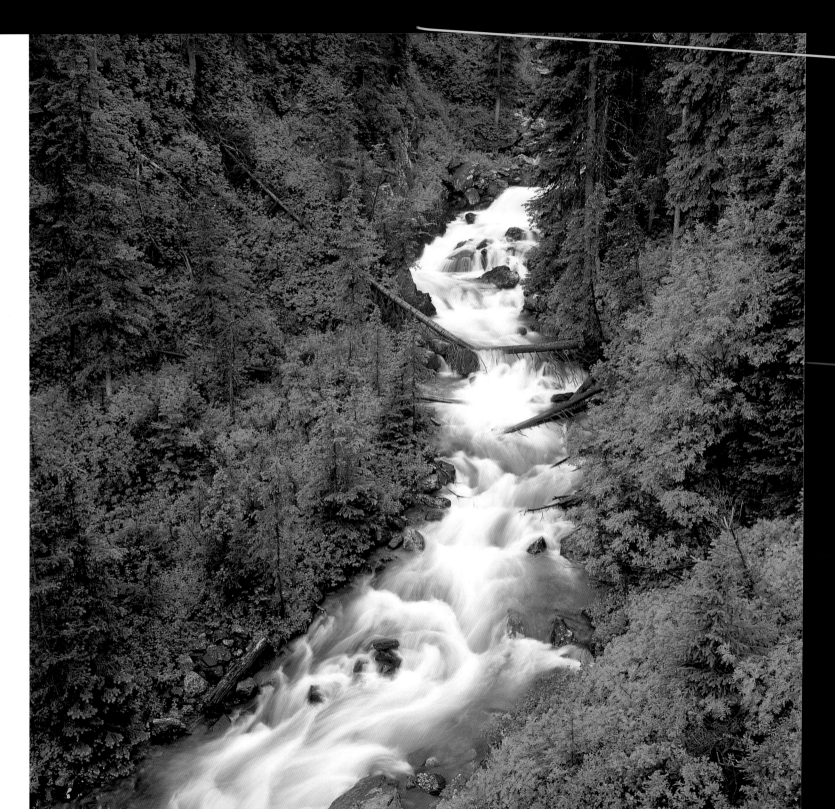

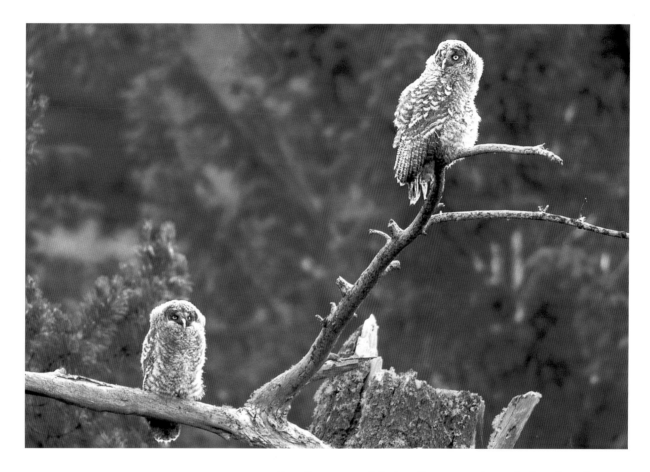

Above: Great gray owl chicks will grow up to be nearly three feet tall.
HENRY H. HOLDSWORTH

Facing page: South Fork of Cascade Creek. FRED PFLUGHOFT

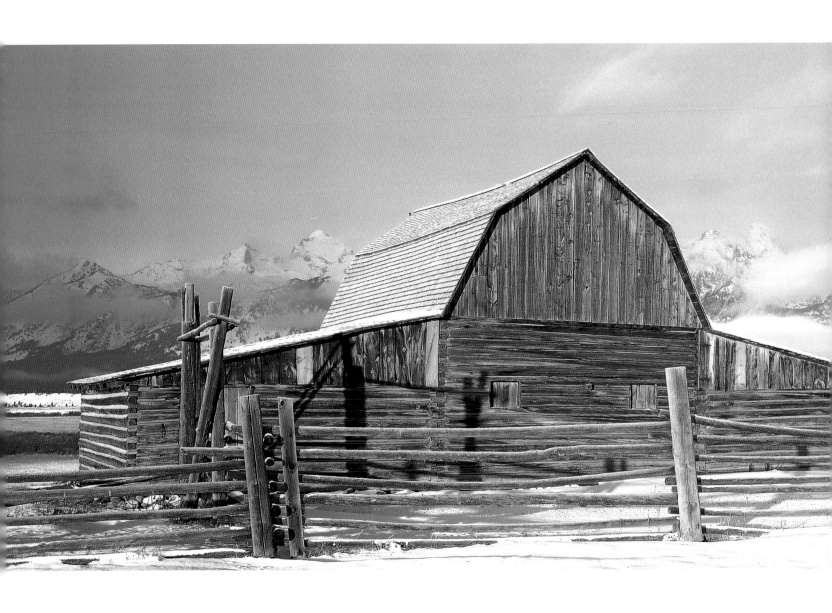

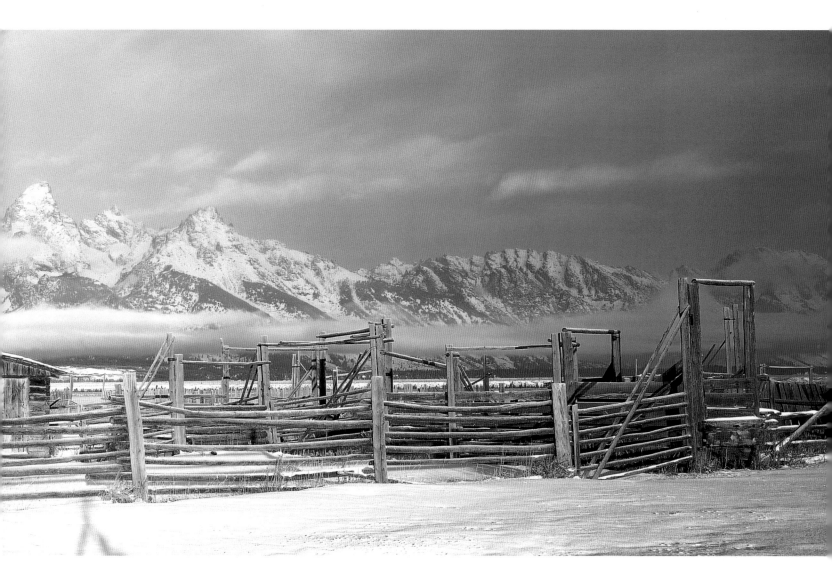

The historic Moulton Barn on Mormon Row marks early homesteading in what became the park. HENRY H. HOLDSWORTH

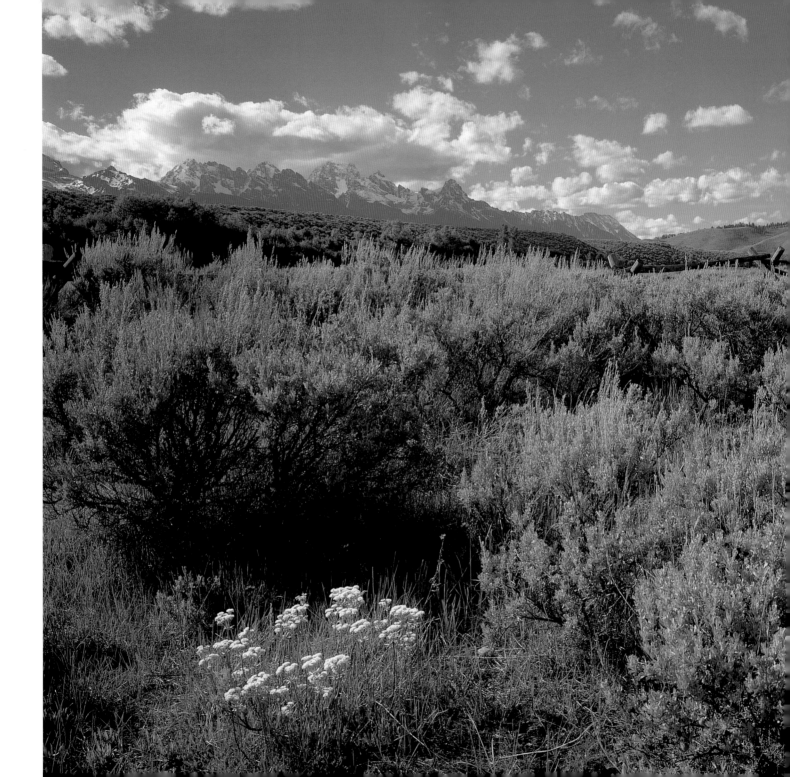

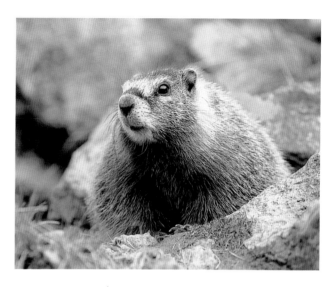

Above: Yellow-bellied marmot, one of the park's twenty-two rodent species. HENRY H. HOLDSWORTH

Left: Looking past Blacktail Butte, near Gros Ventre Junction, to the Tetons. FRED PFLUGHOFT

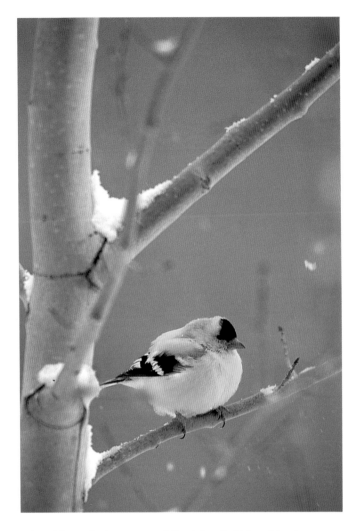

Above: This male American goldfinch has fluffed up his winter insulation. HENRY H. HOLDSWORTH

Right: Aspens and snow-flocked evergreens in Targhee National Forest. HENRY H. HOLDSWORTH

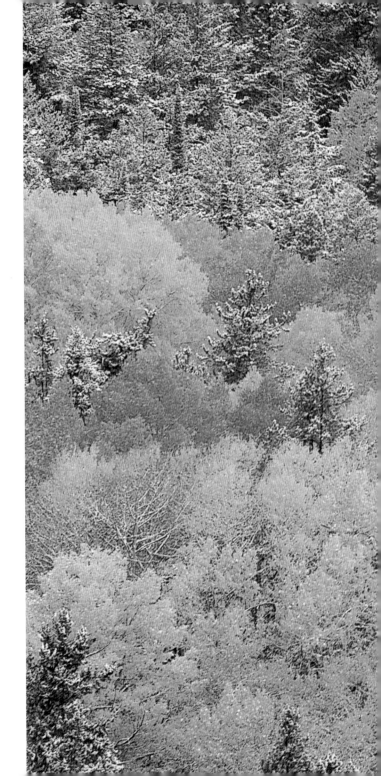

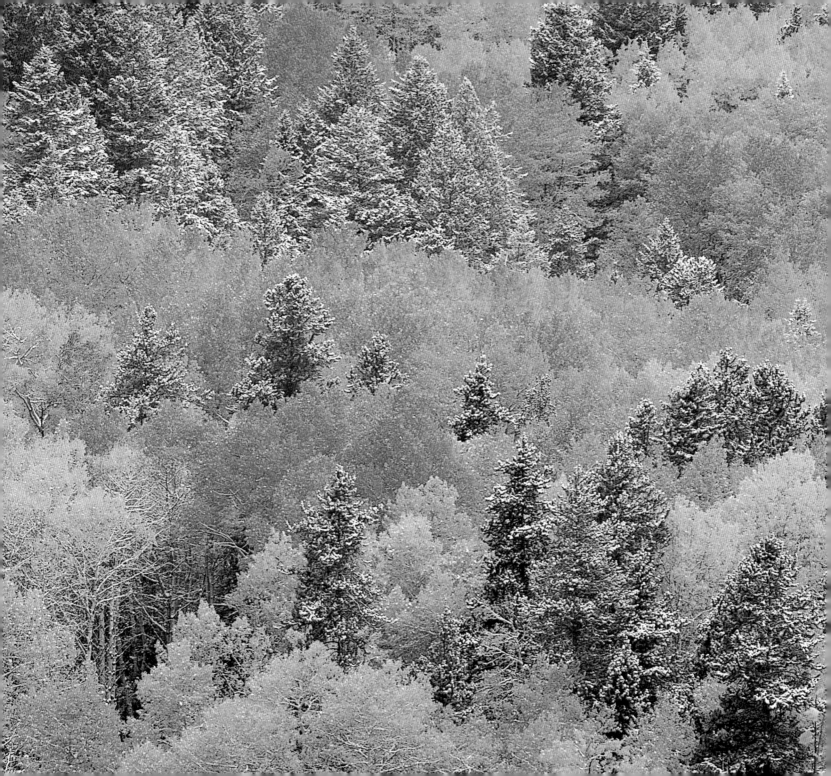

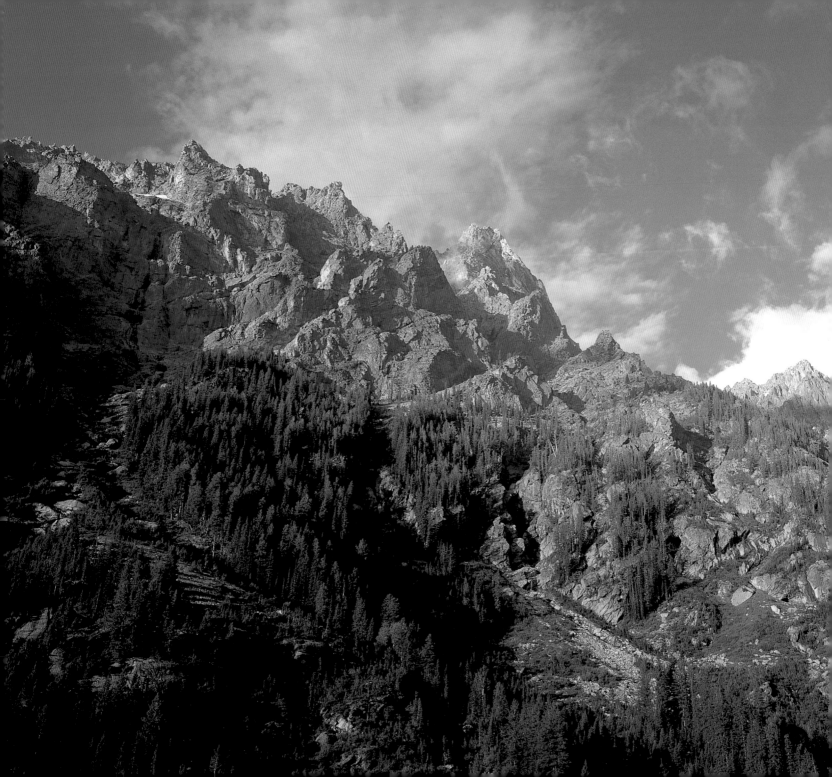

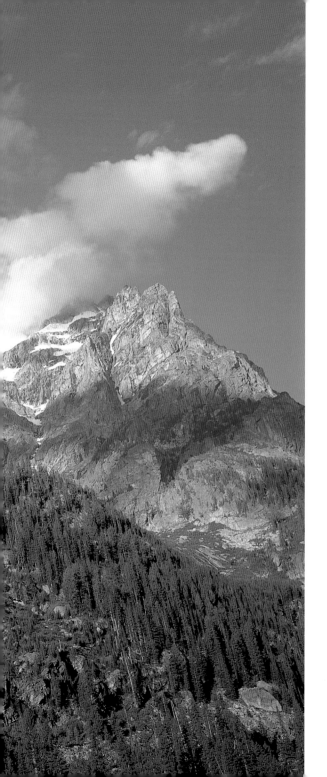

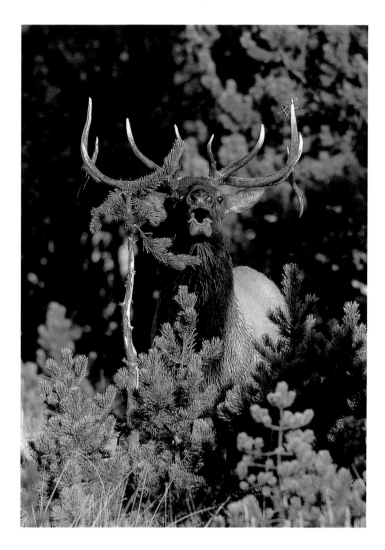

Above: A bull elk bugles for his harem—or to warn off their other potential suitors—by the tree where he's just polished his antlers.
HENRY H. HOLDSWORTH

Left: In Cascade Canyon below the Tetons. FRED PFLUGHOFT

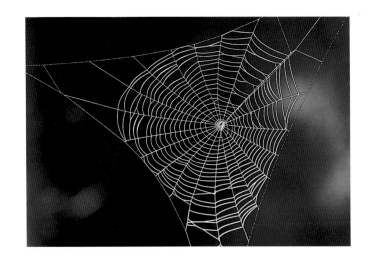

Left: Frost destroys a spider web's camouflage. HENRY H. HOLDSWORTH

Below: Gray wolves cross the National Elk Refuge. HENRY H. HOLDSWORTH

Facing page: Chapel of the Transfiguration, near Moose, dates from 1925. FRED PFLUGHOFT

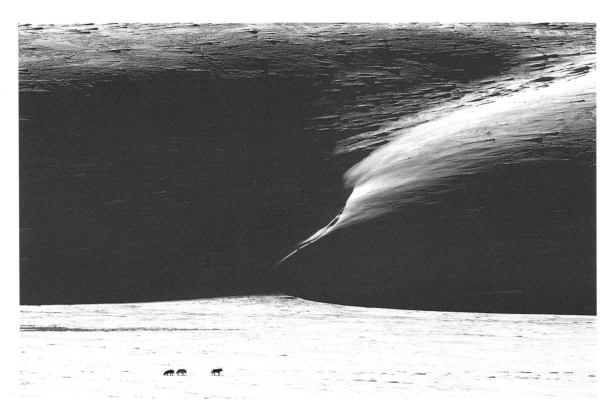

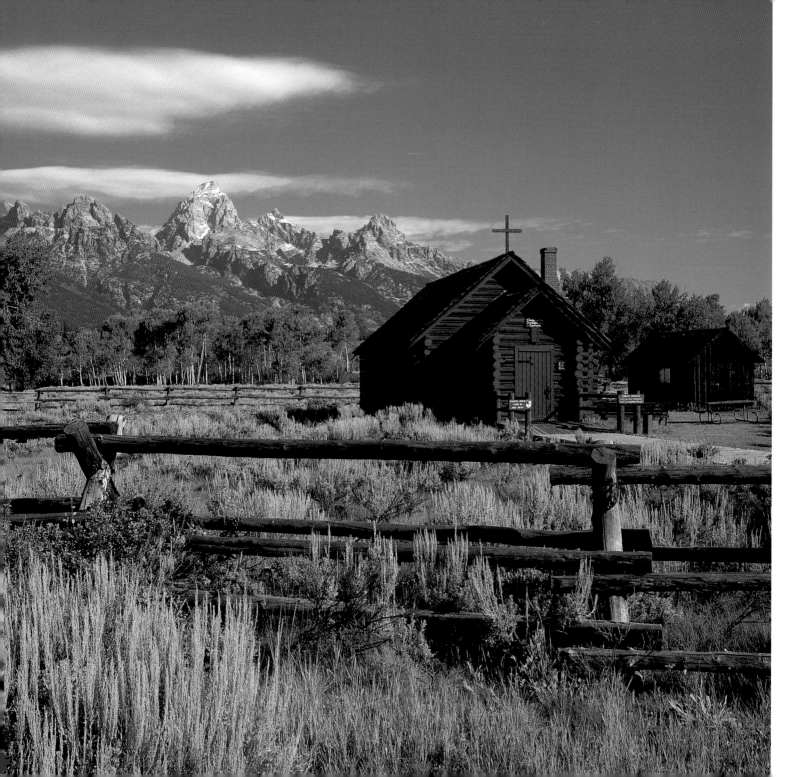

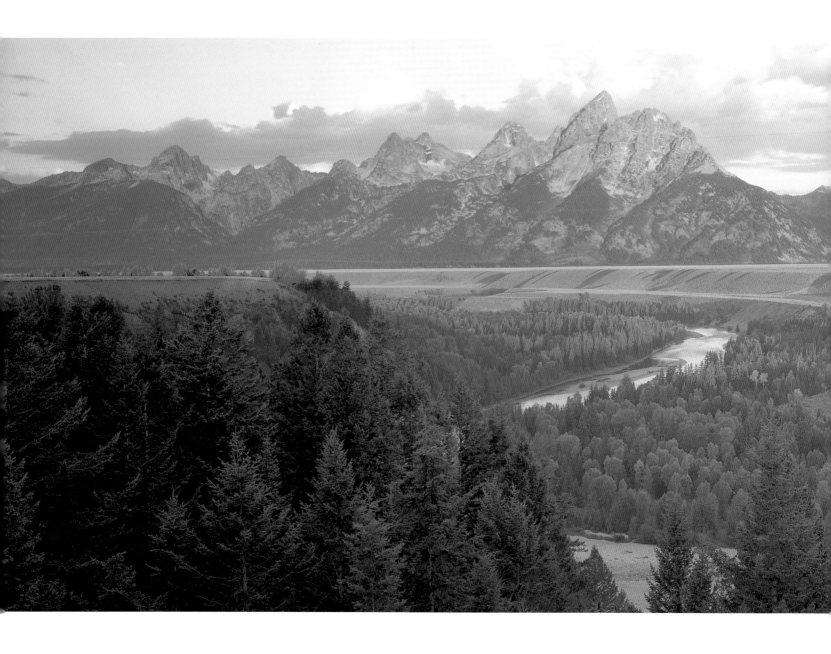

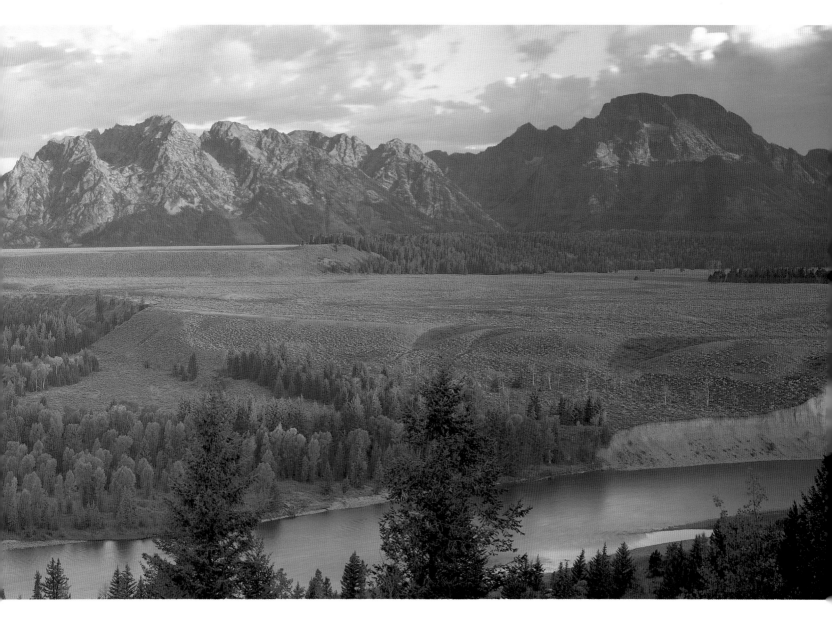

Autumn view of the Tetons from Snake River Overlook.

HENRY H. HOLDSWORTH

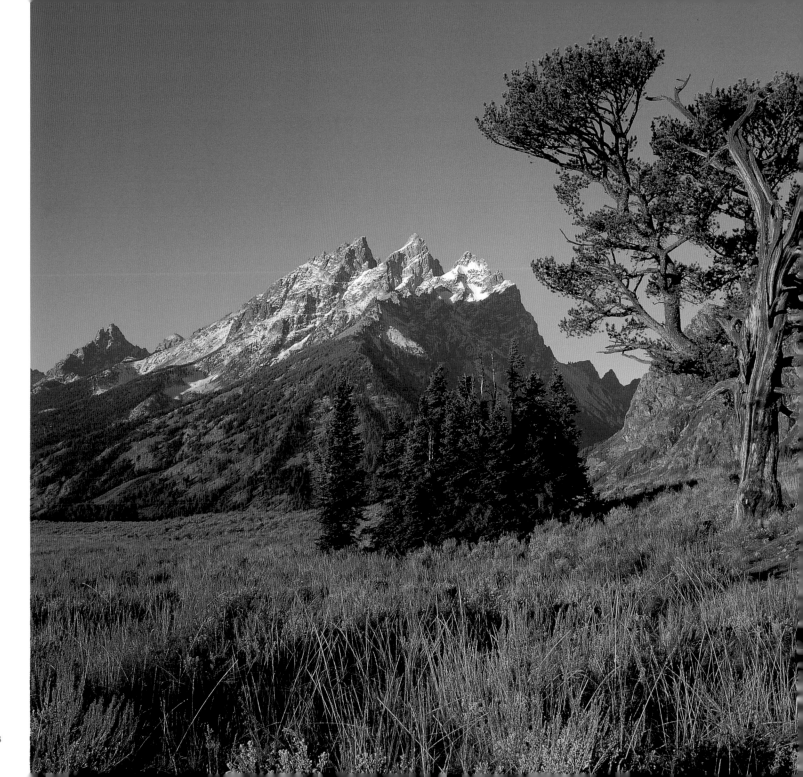

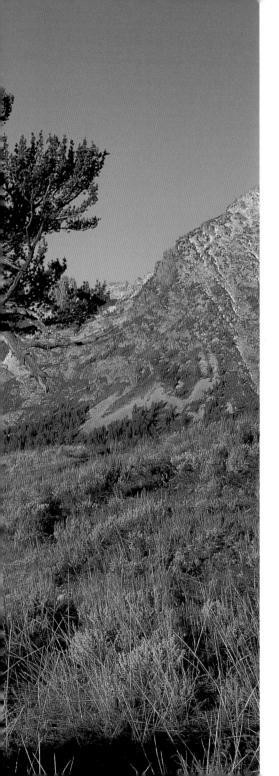

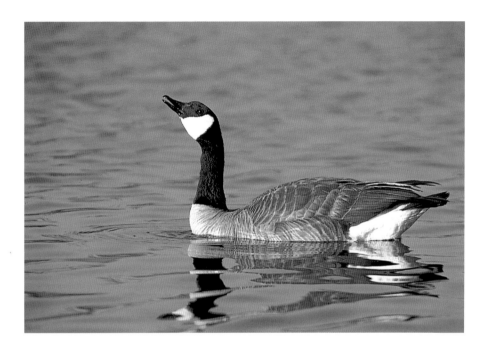

Above: At the National Elk Refuge, a Canada goose pauses for a drink. HENRY H. HOLDSWORTH

Left: "The Patriarch," famous old pine tree, and the "Cathedral" view of three of the highest Teton peaks. FRED PFLUGHOFT

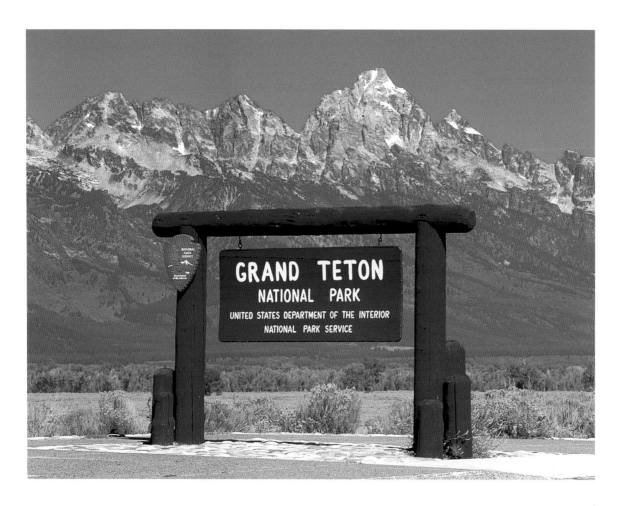

Above: The park's South Entrance, near Jackson, reveals magnificence beyond.
HENRY H. HOLDSWORTH

Facing page: Looking north from South Fork of Cascade Canyon. FRED PFLUGHOFT

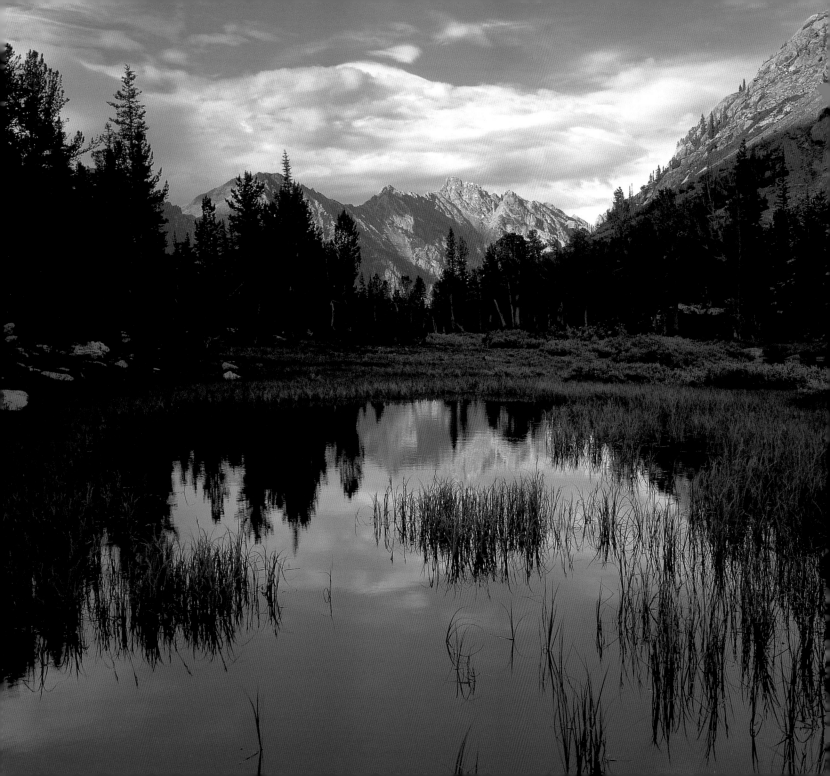

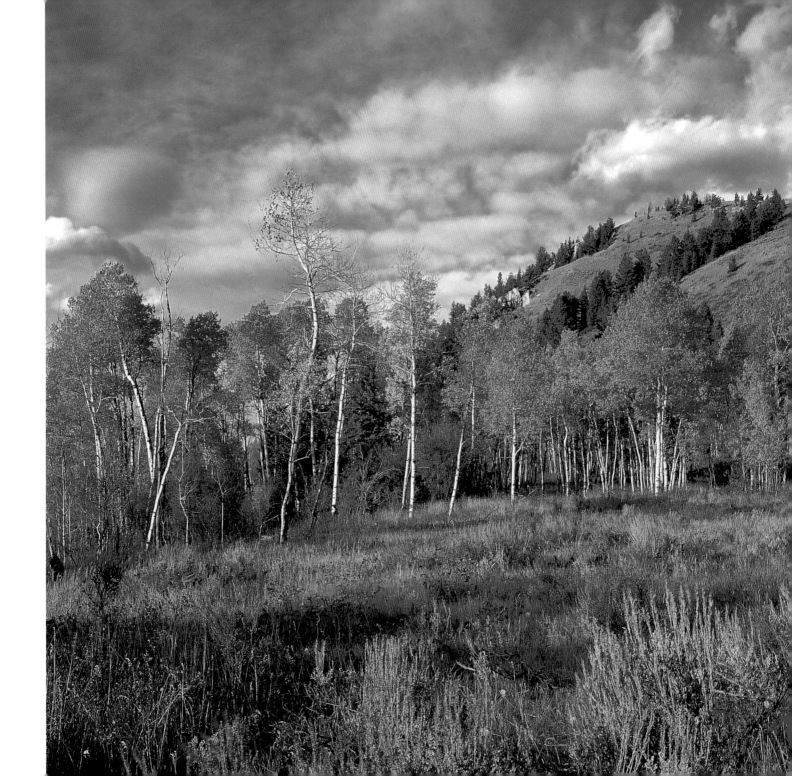

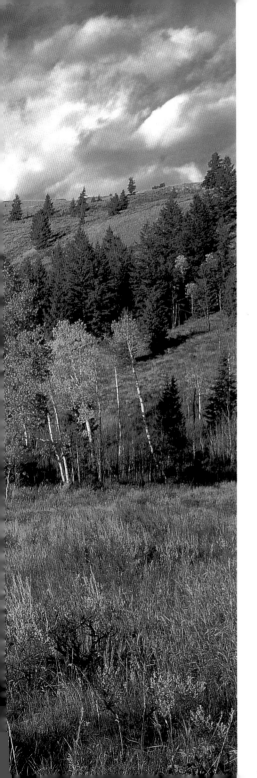

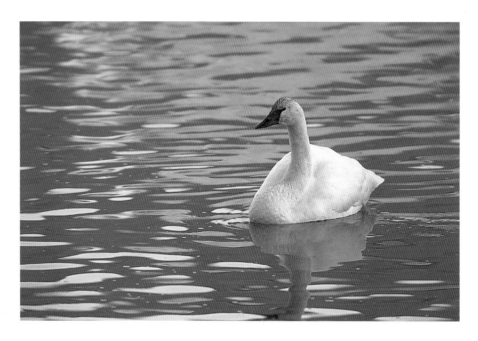

Above: Trumpeter swan on sunset-tinted Flat Creek; they stop here in November and stay until freeze-up, and return to nest in spring. HENRY H. HOLDSWORTH

Left: Blacktail Butte and autumn glory. FRED PFLUGHOFT

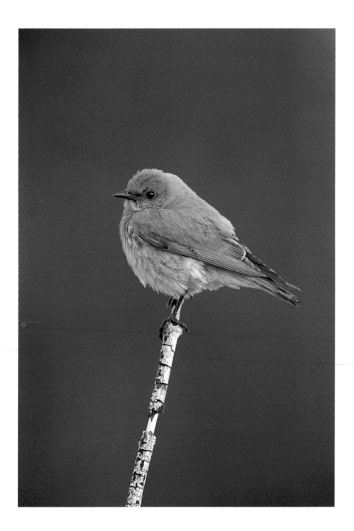

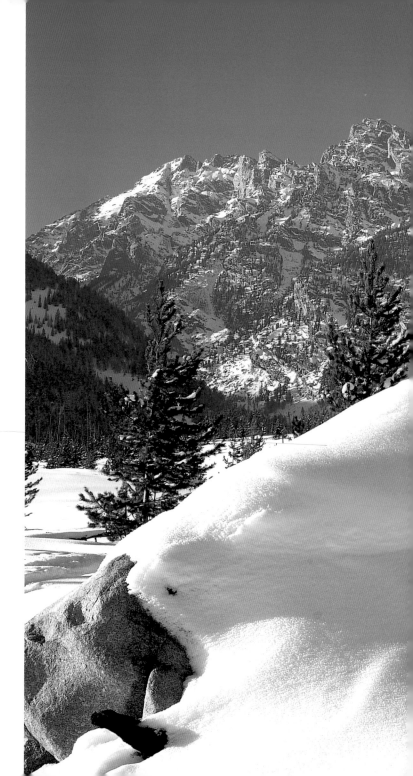

Above: Male mountain bluebird, a harbinger of spring.
HENRY H. HOLDSWORTH

Right: Near Taggart Lake. FRED PFLUGHOFT

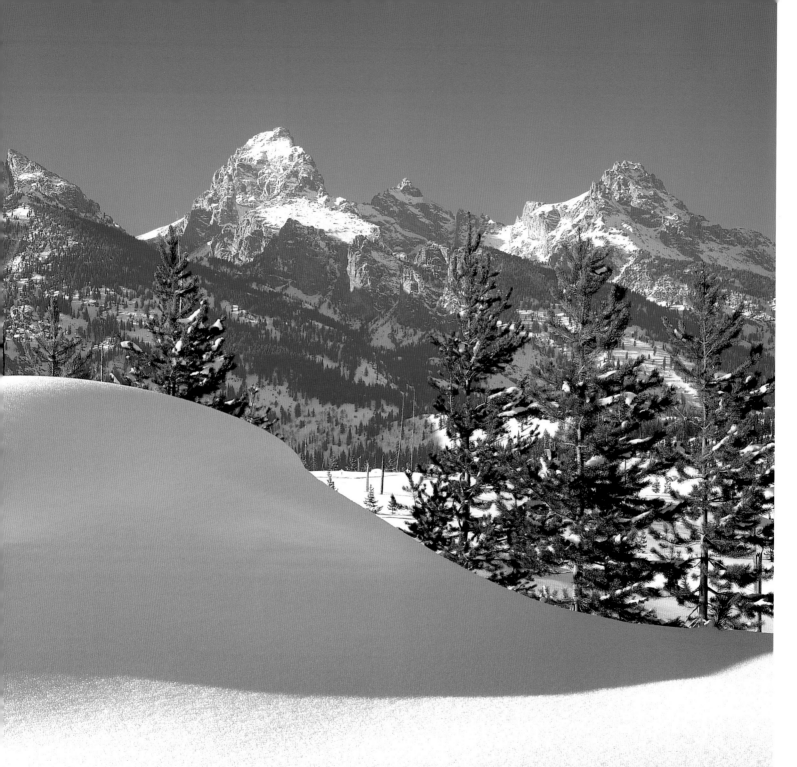

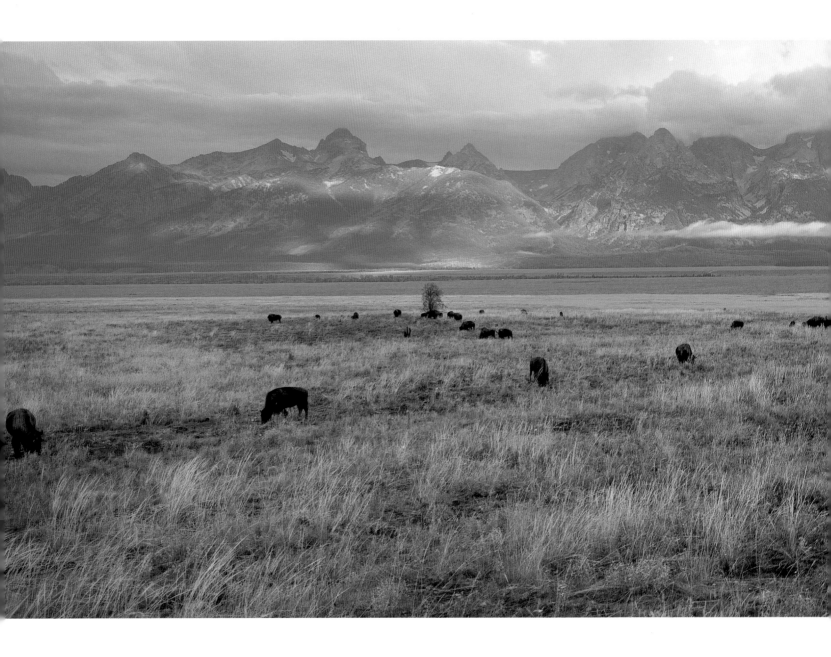

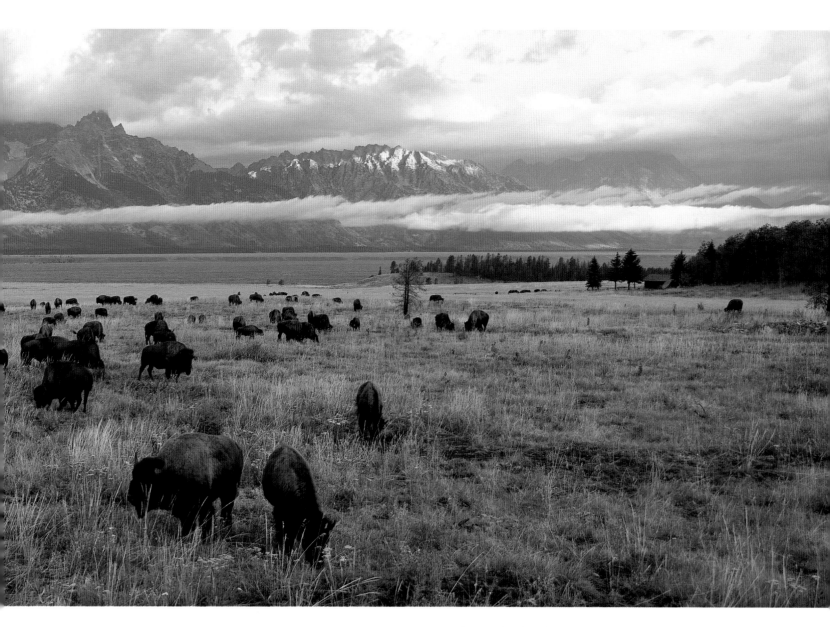

Jackson Hole's bison herd. HENRY H. HOLDSWORTH

Right: Christian Creek flows near Jackson Lake Lodge. FRED PFLUGHOFT

Below: Moose, like this cow and her calf, graze on creek bottom treats.
HENRY H. HOLDSWORTH

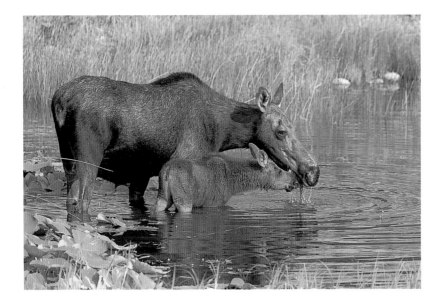

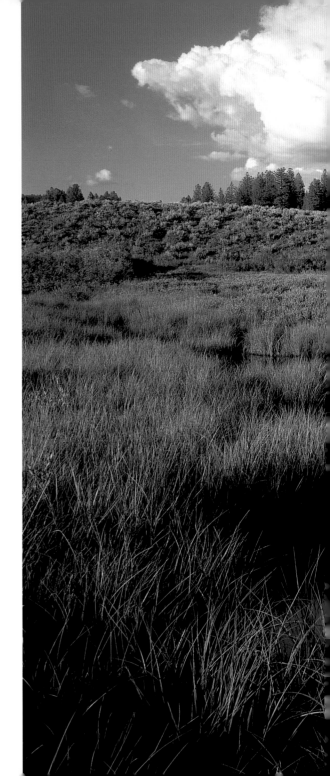

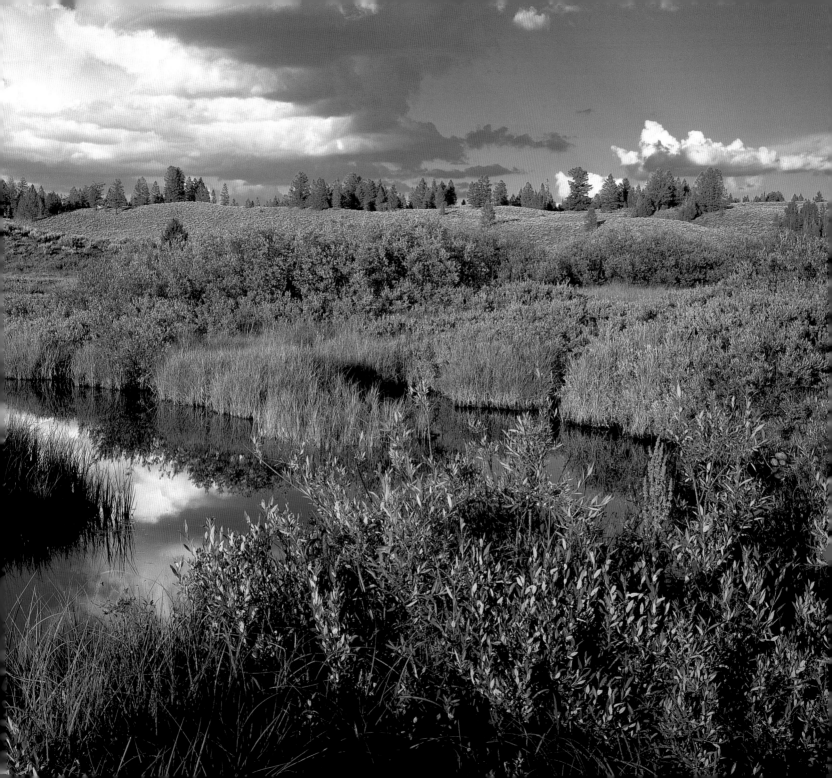

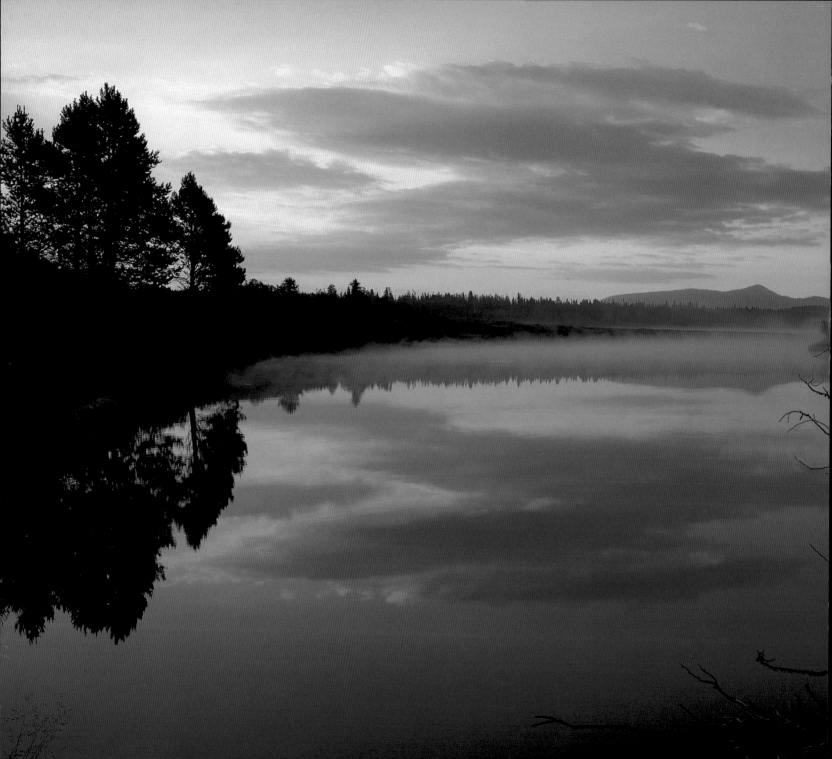

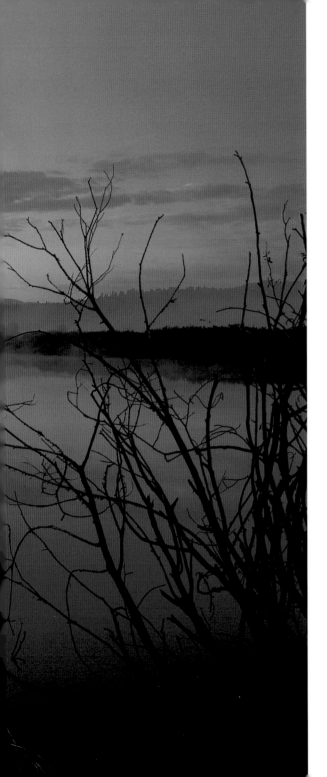

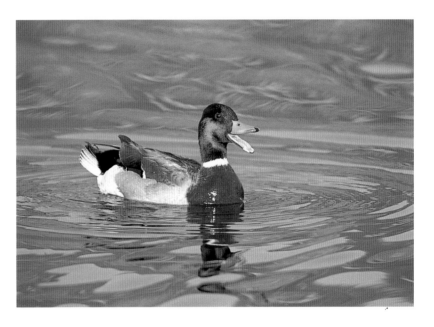

Above: A male mallard duck announces his presence in the National Elk Refuge.
HENRY H. HOLDSWORTH

Left: The Snake River's Oxbow Bend on a cool and peaceful morning.
FRED PFLUGHOFT

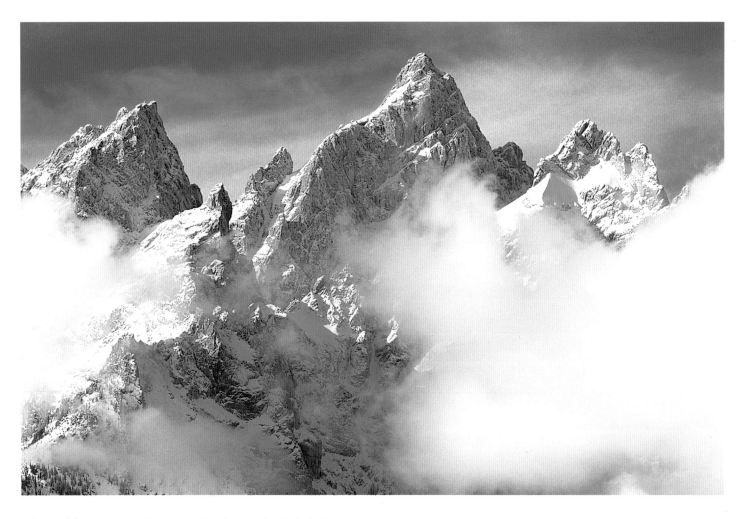

Above: A fall snowstorm clears away after dusting the Cathedral Group.
HENRY H. HOLDSWORTH

Facing page: Hidden Falls trips out of Cascade Canyon. FRED PFLUGHOFT

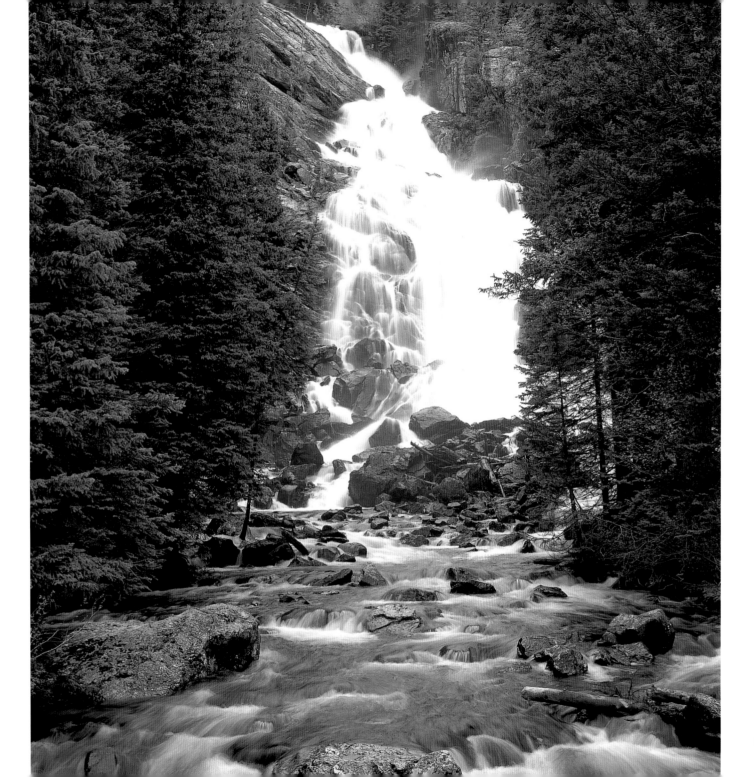

Sunset silhouettes Mount Moran
above Oxbow Bend. FRED PFLUGHOFT

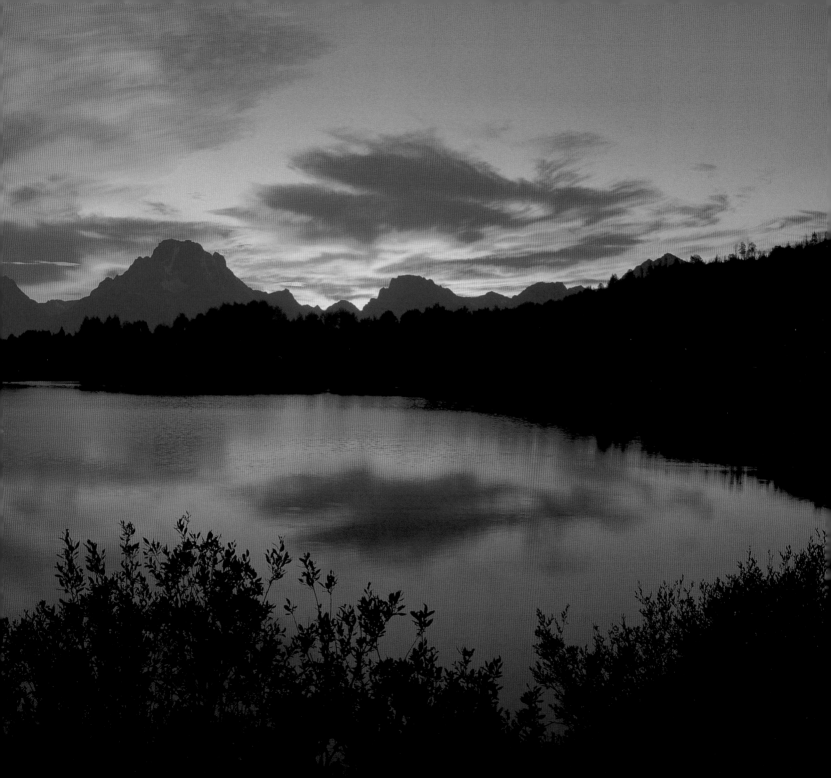

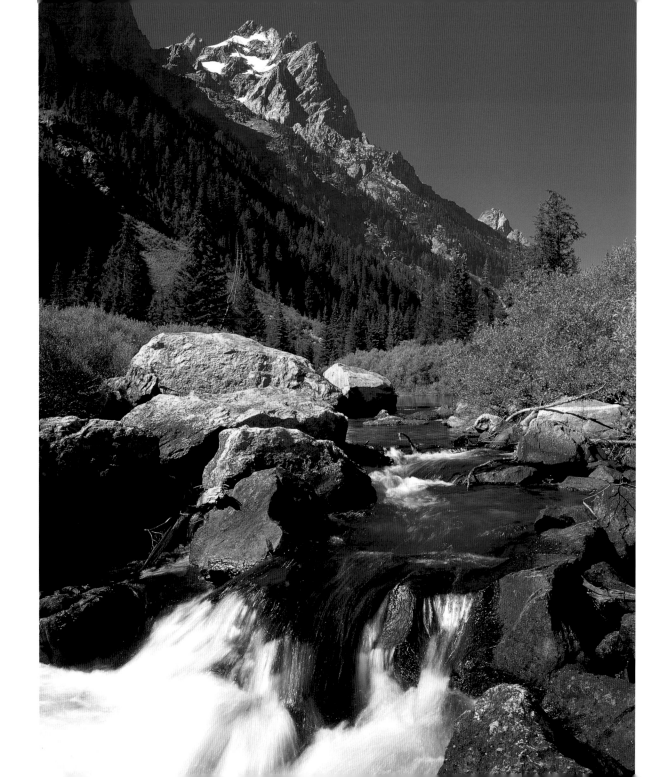

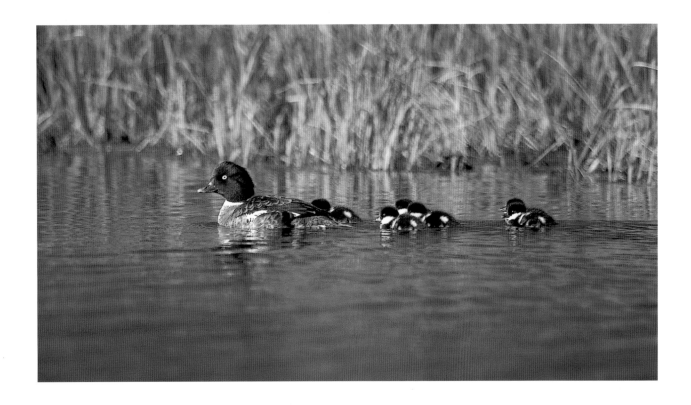

Above: Mama and her young fleet of Barrow's goldeneyes. FRED PFLUGHOFT

Right: The Cunningham cabin remains from a homestead of the early 1900s. HENRY H. HOLDSWORTH

Facing page: Mount Owen, after the Grand Teton, is the Teton Range's second-highest peak. FRED PFLUGHOFT

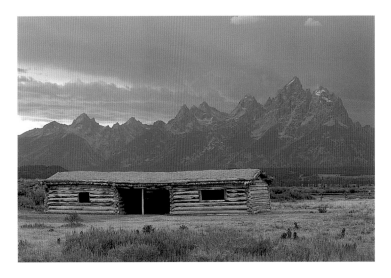

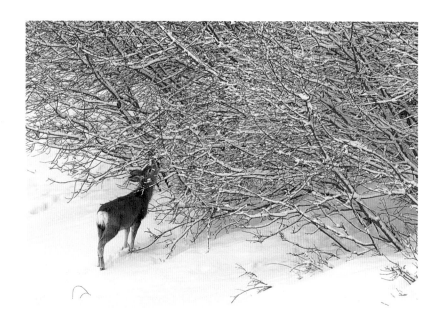

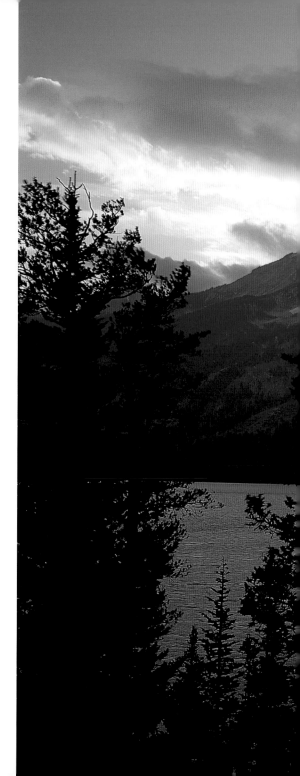

Above: Spring snow sends a fawn's food search upward. HENRY H. HOLDSWORTH

Right: Jenny Lake. FRED PFLUGHOFT

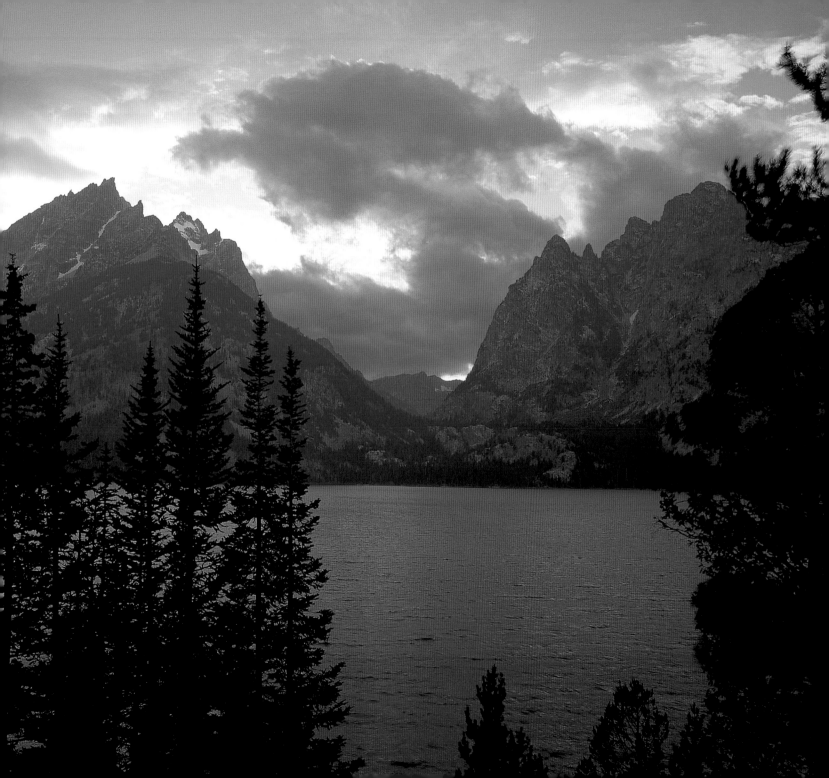

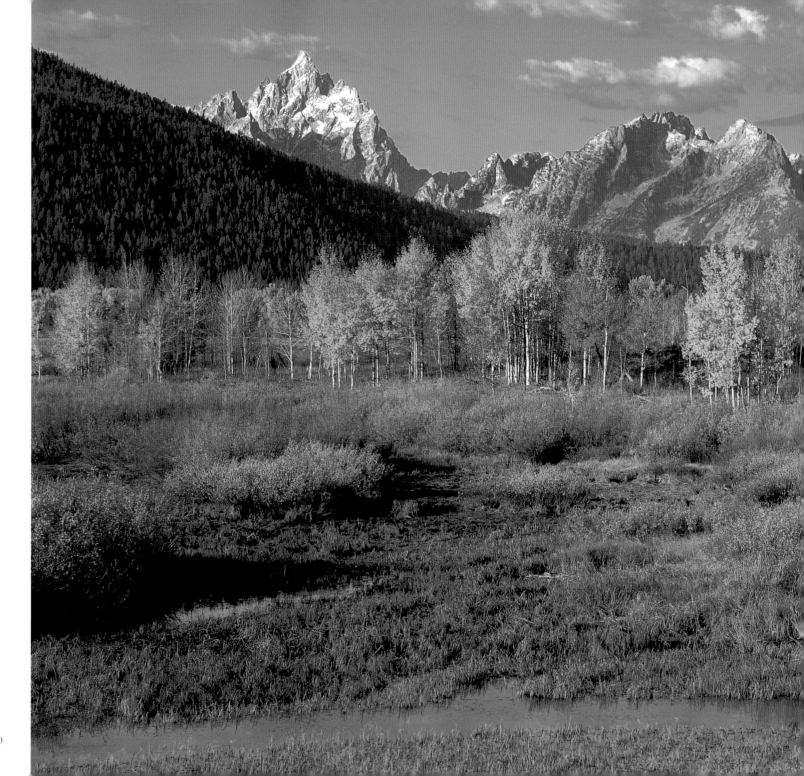

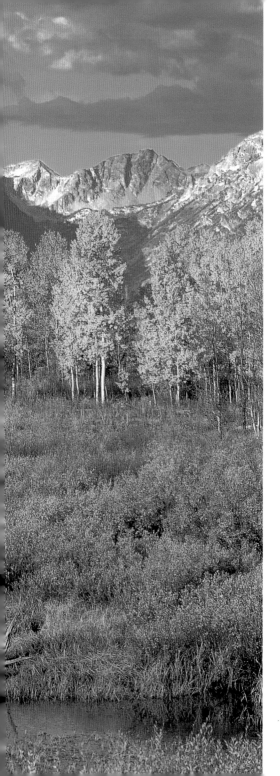

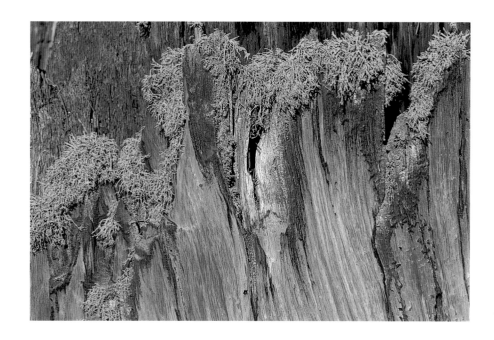

Above: Lichen on an opportune tree stump. HENRY H. HOLDSWORTH

Left: Aspens and the Tetons from Oxbow Bend. FRED PFLUGHOFT

41

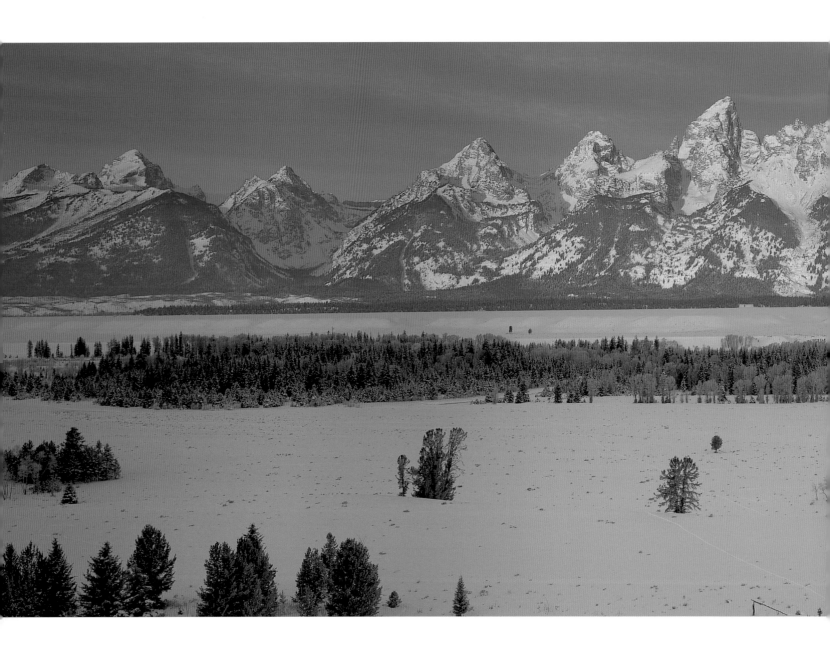

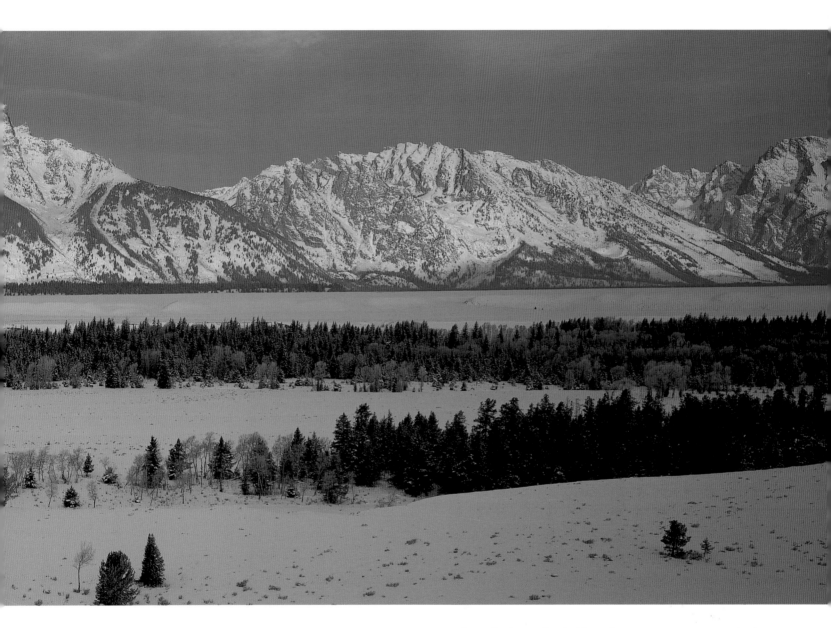

A frosty day begins for the Teton Range. HENRY H. HOLDSWORTH

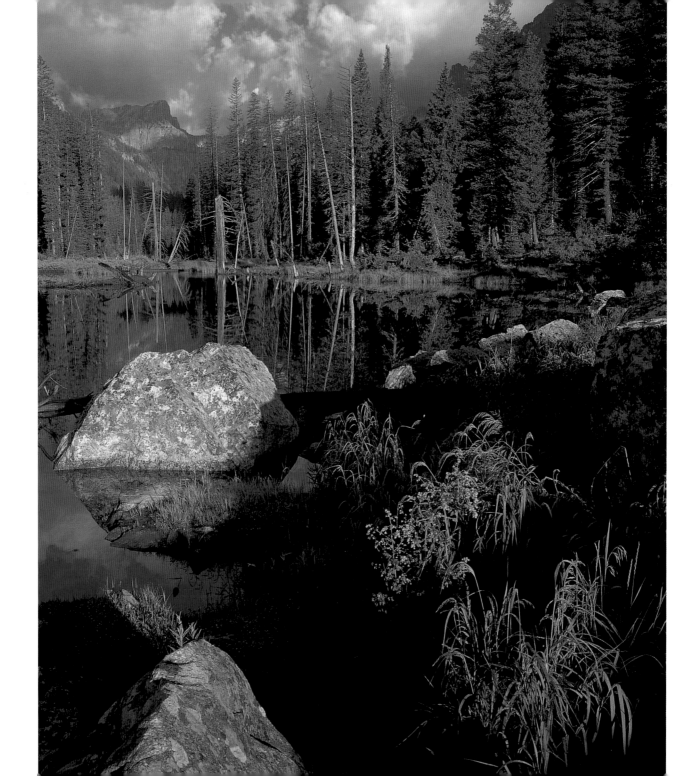

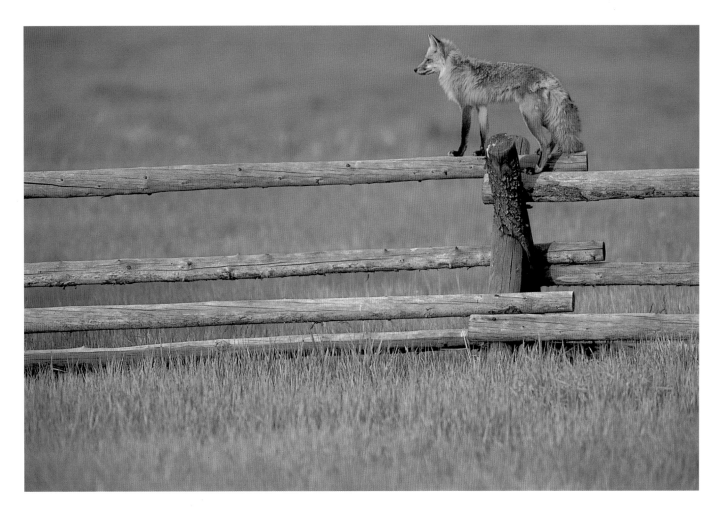

Above: This smart fox will use whatever hunting advantages present themselves. HENRY H. HOLDSWORTH

Facing page: Promise of a stormy day in Cascade Canyon. FRED PFLUGHOFT

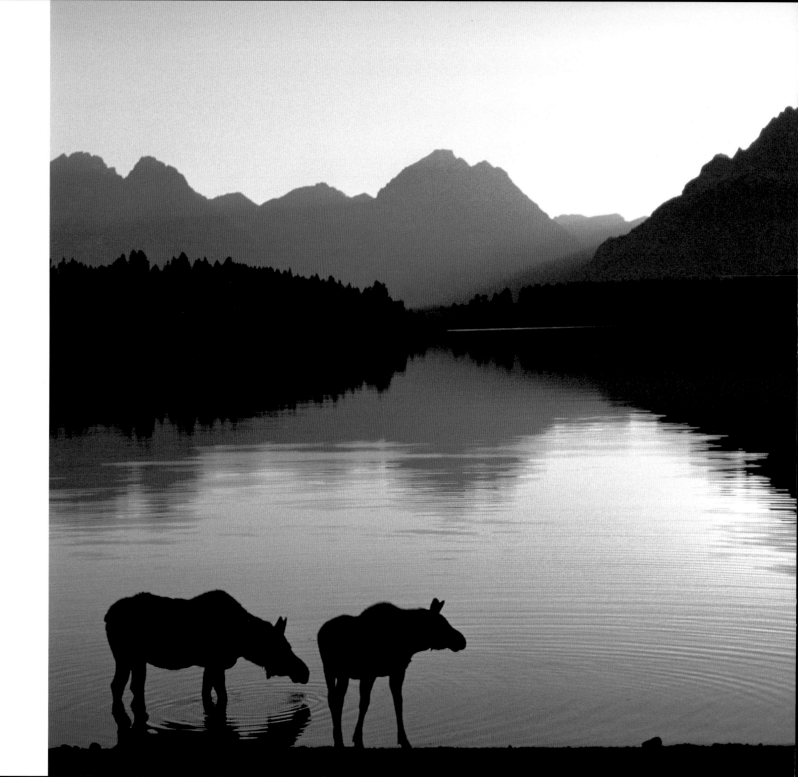

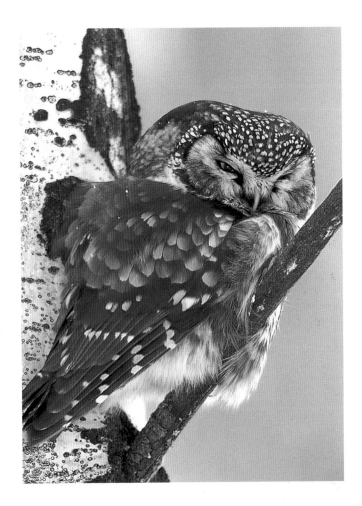

Above: Boreal owl clings tightly to an aspen perch.
HENRY H. HOLDSWORTH

Left: Moose cow and calf in Jackson Lake on an especially quiet October evening. HENRY H. HOLDSWORTH

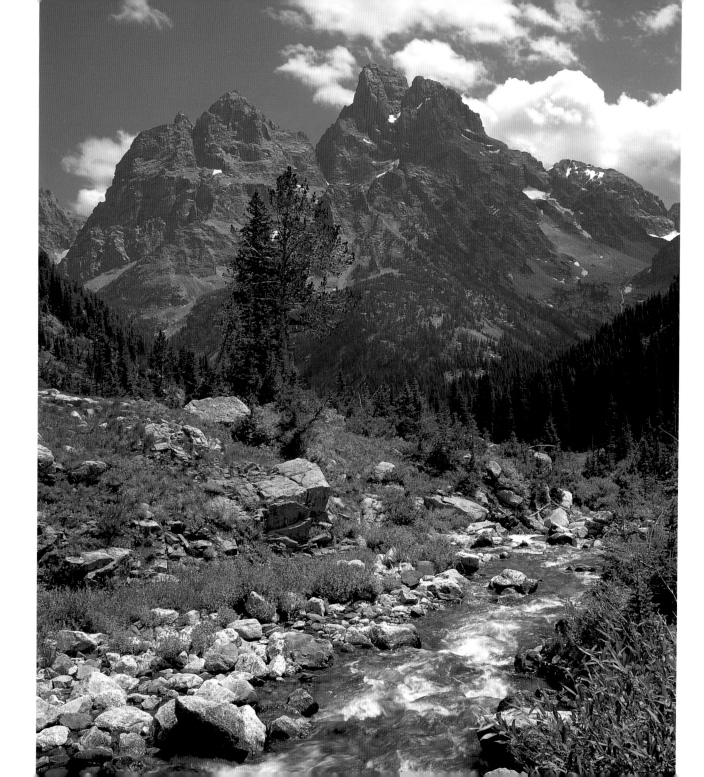

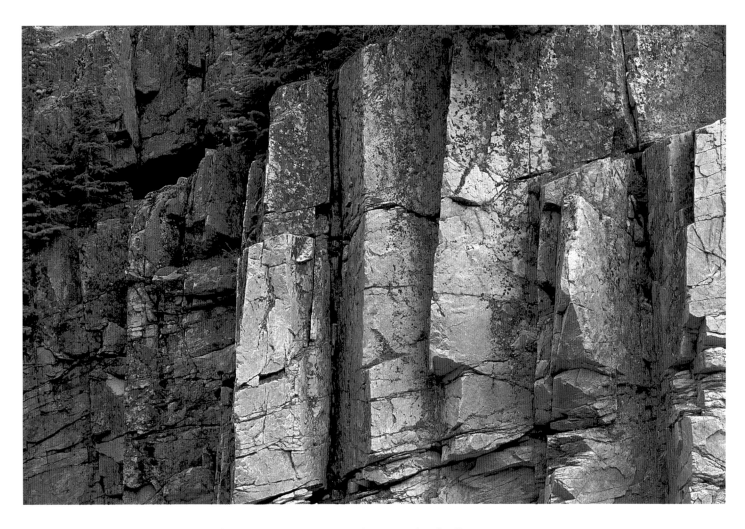

Above: Natural rock pillars. FRED PFLUGHOFT

Facing page: A Tetons skyline from North Fork of Cascade Creek. FRED PFLUGHOFT

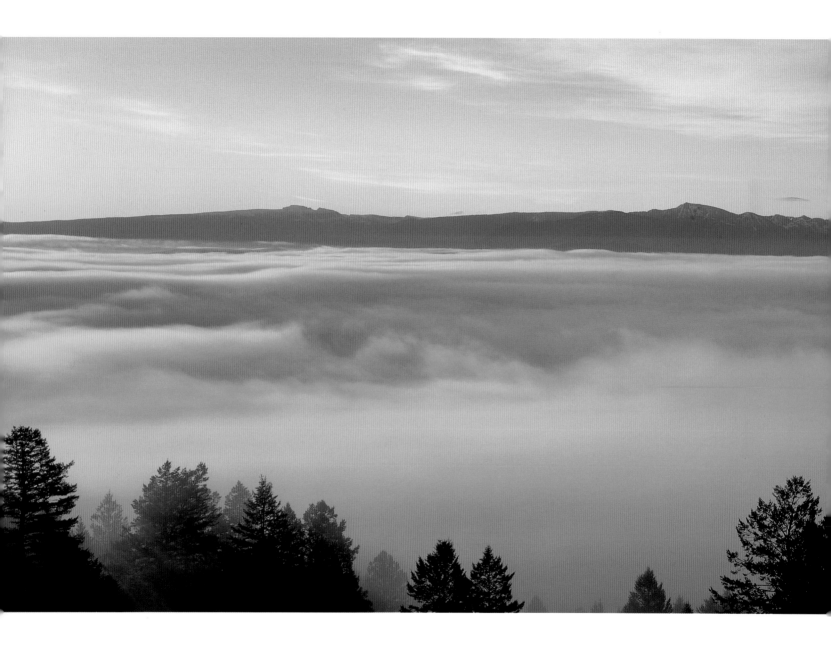

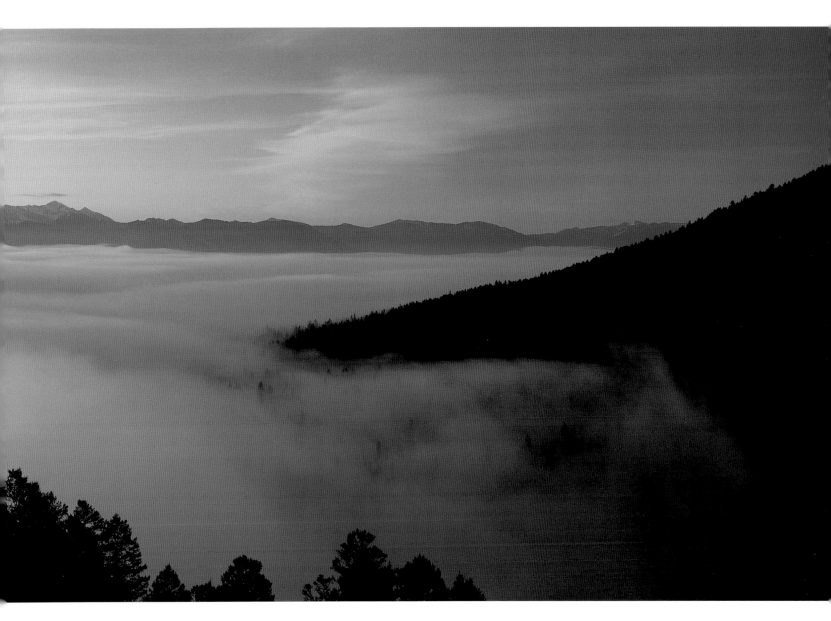

Fogged-in Jackson Hole, viewed from Teton Pass. HENRY H. HOLDSWORTH

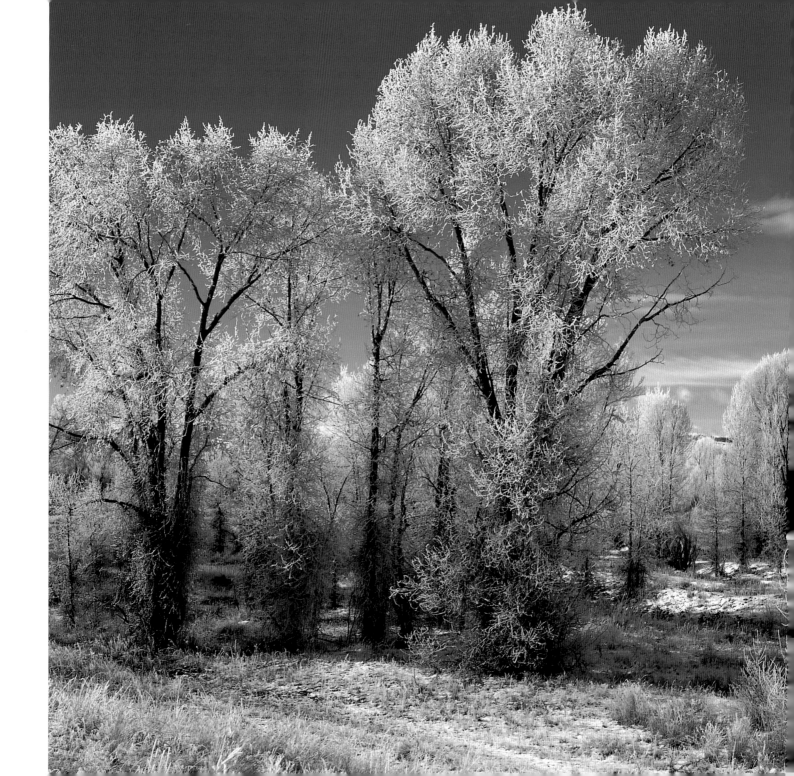

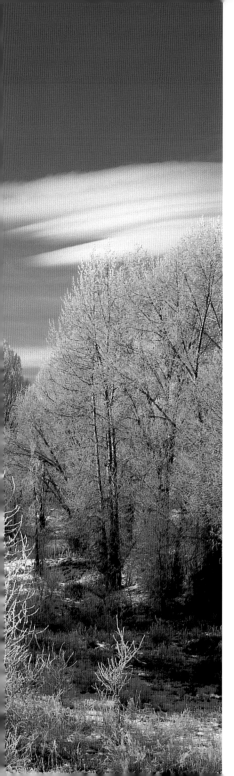

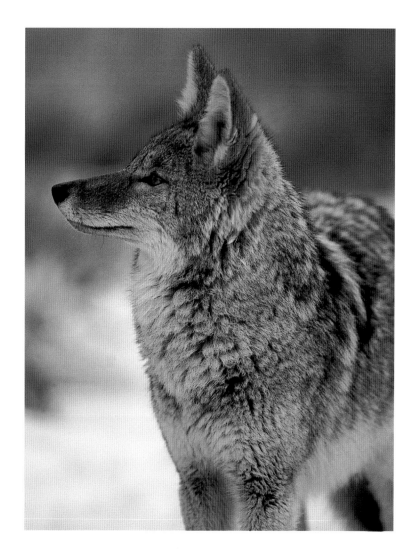

Above: Coyotes are very adaptable, and live throughout the park.
HENRY H. HOLDSWORTH

Left: Cottonwood trees receive a frosty sparkle. FRED PFLUGHOFT

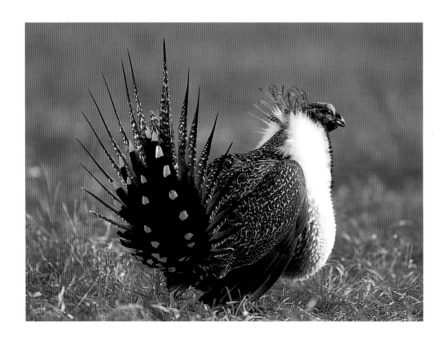

Above: A male sage grouse gives his best courting strut. HENRY H. HOLDSWORTH

Right: Climb Signal Mountain for this view of sunrise on the Tetons. FRED PFLUGHOFT

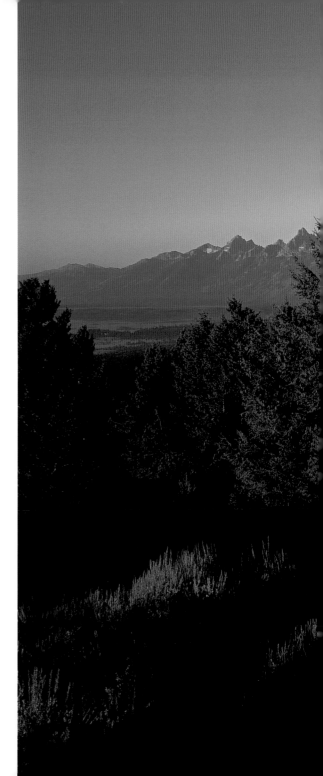

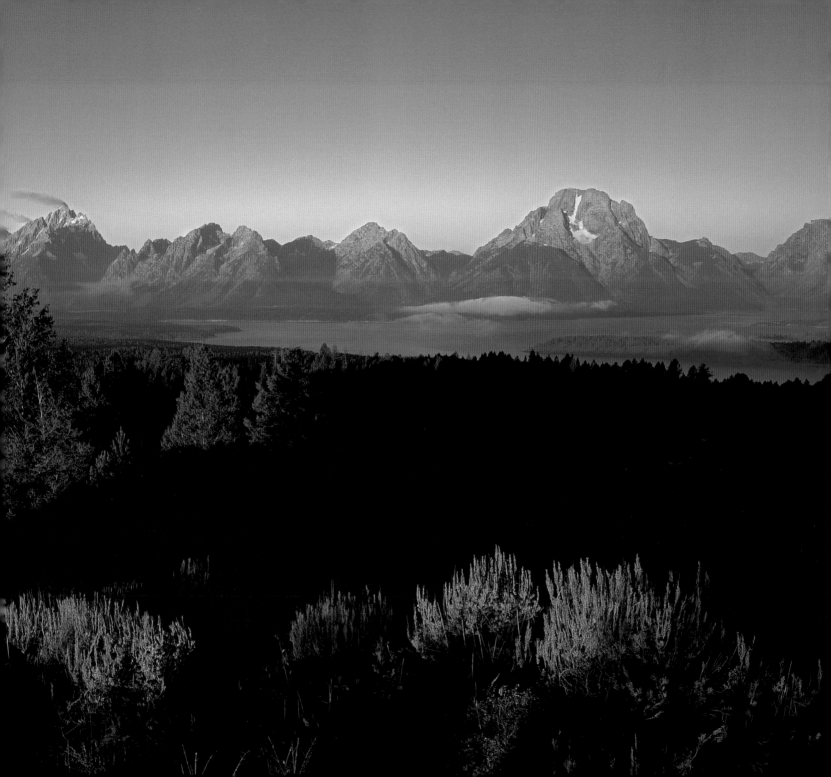

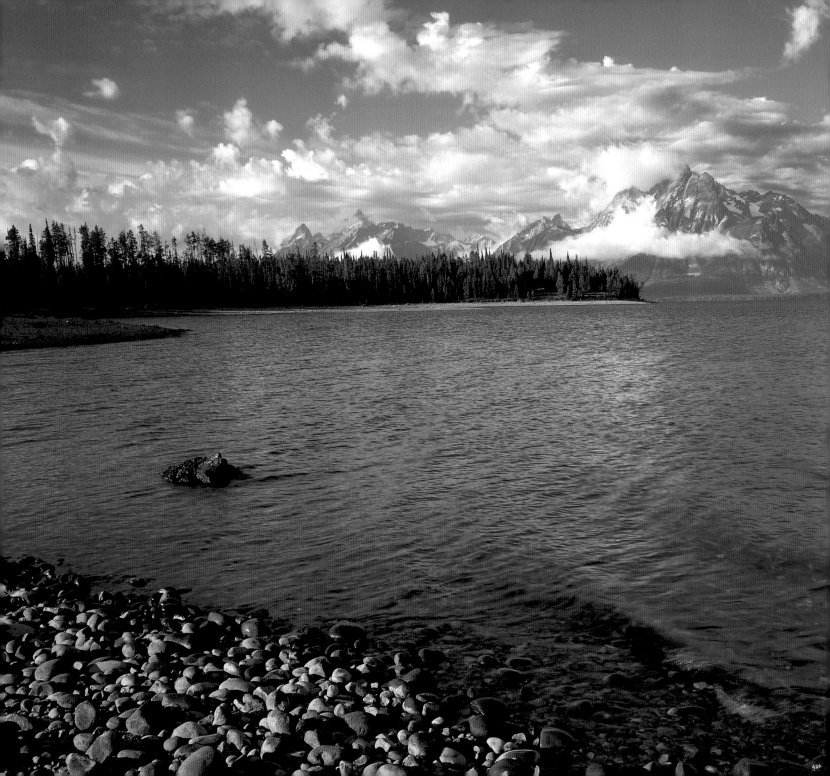

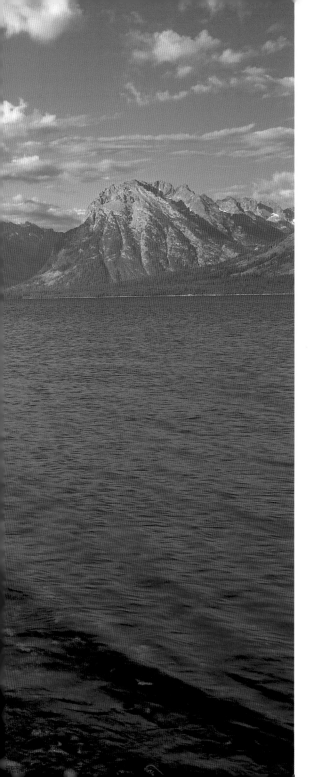

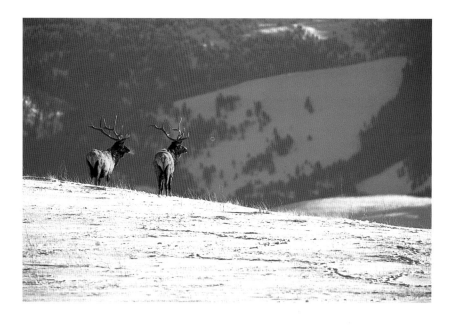

Above: Bull elk on the alert. HENRY H. HOLDSWORTH

Left: Clouds crowd the Tetons beyond Jackson Lake. FRED PFLUGHOFT

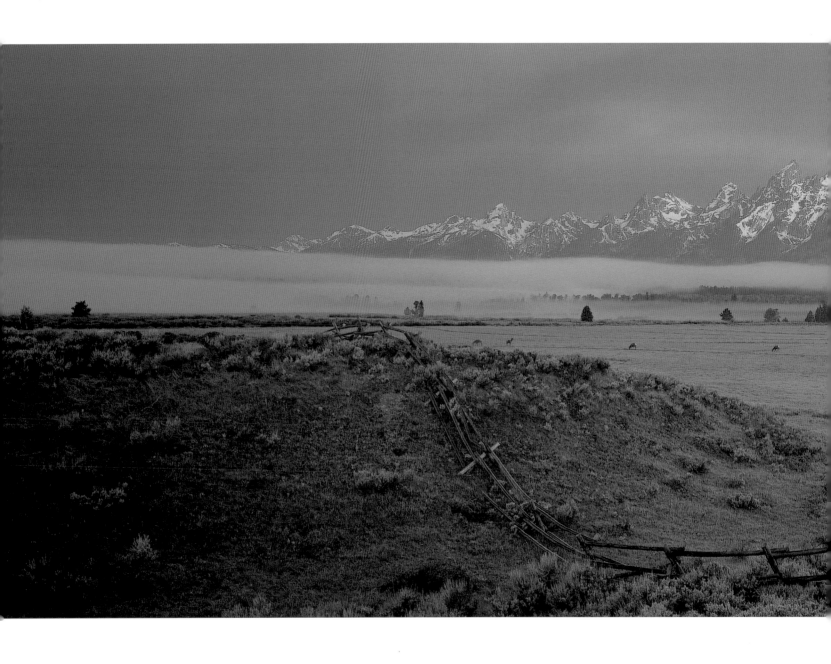

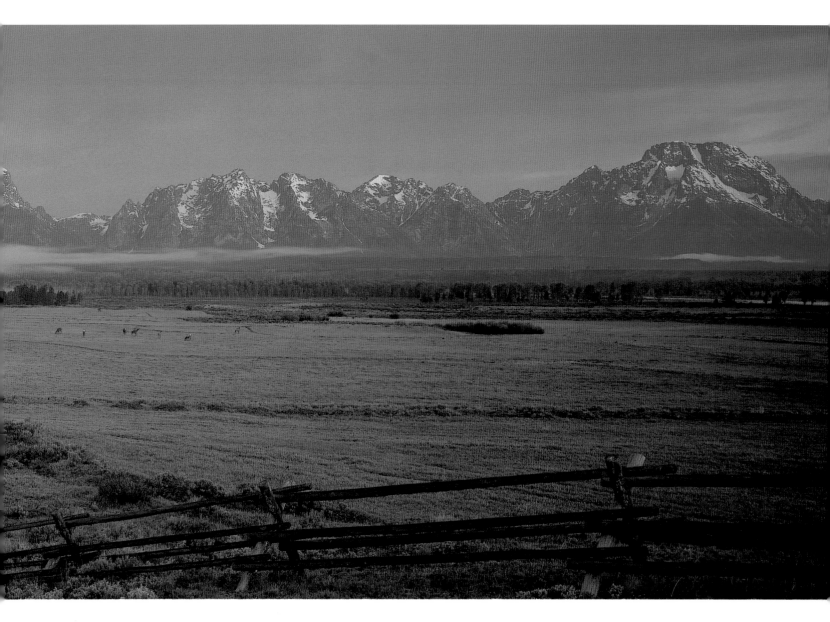

Elk graze the Triangle X Guest Ranch for breakfast. HENRY H. HOLDSWORTH

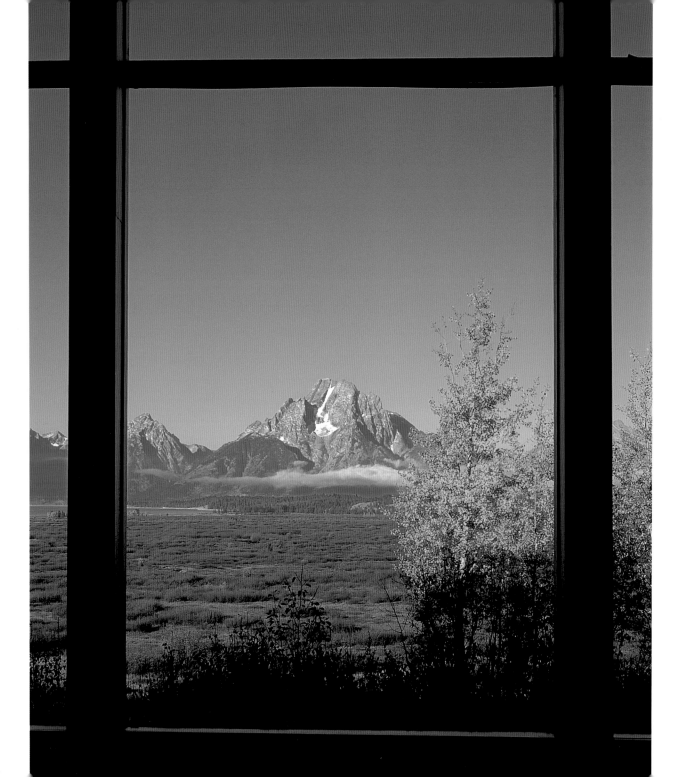

Above: Whispery aspen leaves change to their autumn tones.
FRED PFLUGHOFT

Facing page: Visitors to Jackson Lake Lodge can enjoy this view
of Mount Moran. FRED PFLUGHOFT

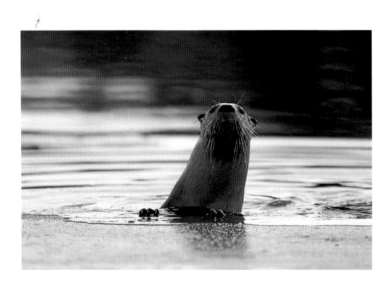

Above: River otters in the park always seem to be having a good time. HENRY H. HOLDSWORTH

Right: Heron Pond captures images of a change in the weather. FRED PFLUGHOFT

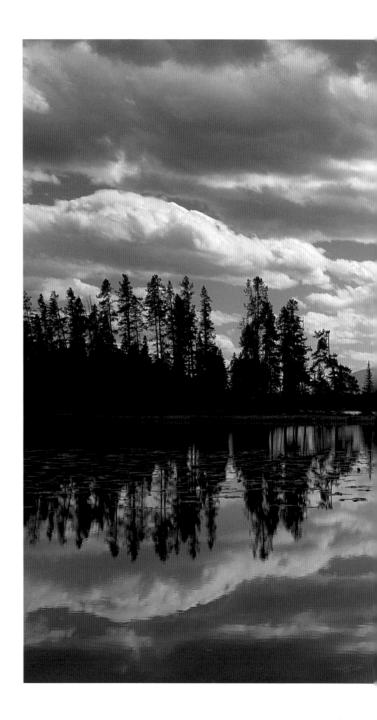

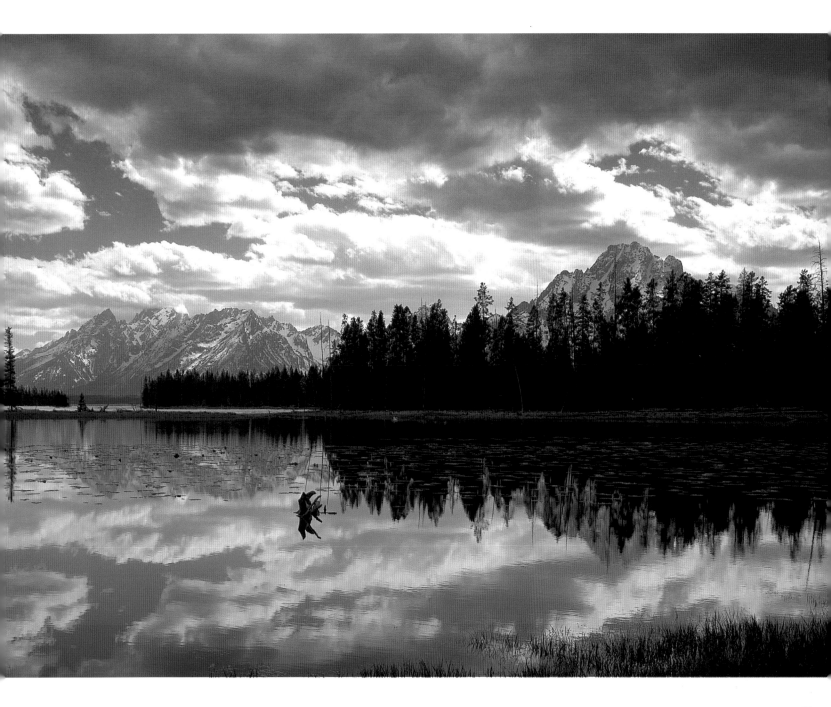

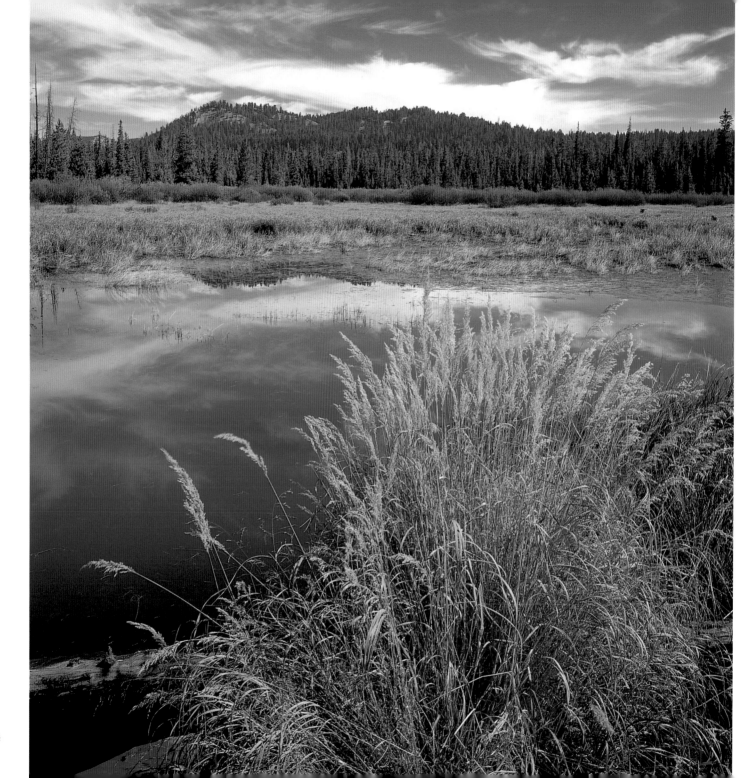

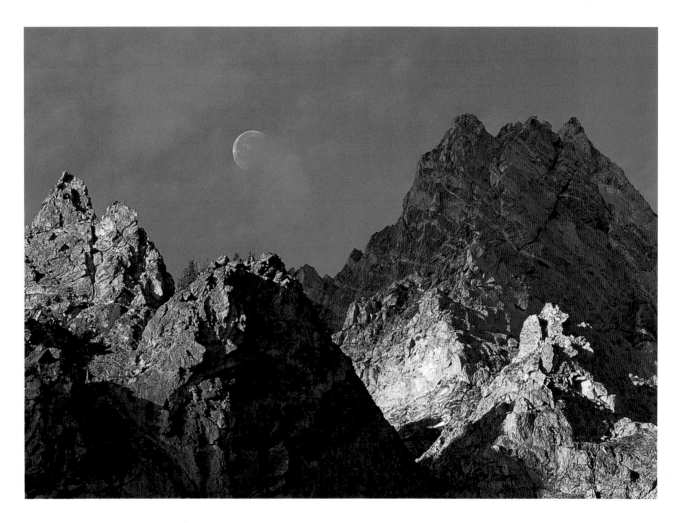

Above: Teewinot Mountain's name comes from the Shoshone meaning "many pinnacles." FRED PFLUGHOFT

Facing page: Grand View Point reflected in an unnamed pond near Jackson Lake Lodge. FRED PFLUGHOFT

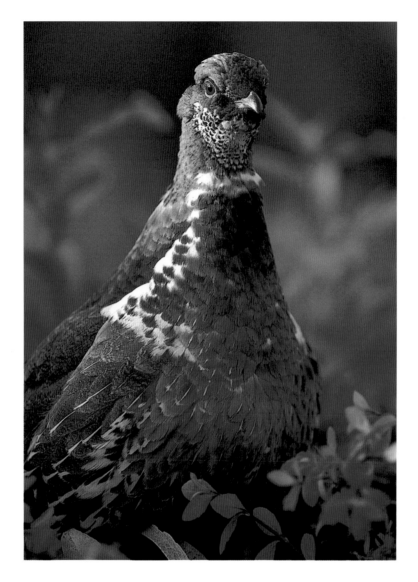

Above: Blue grouse male fluffs his feathers for the spring mating ritual.

Facing page: Lake Solitude lies below the Tetons in Cascade Canyon.

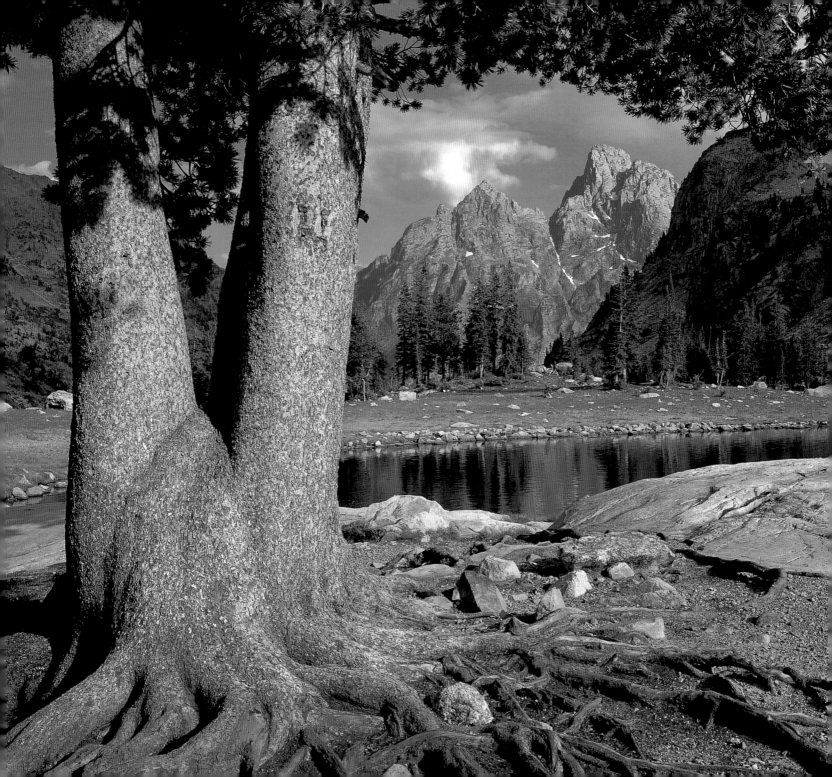

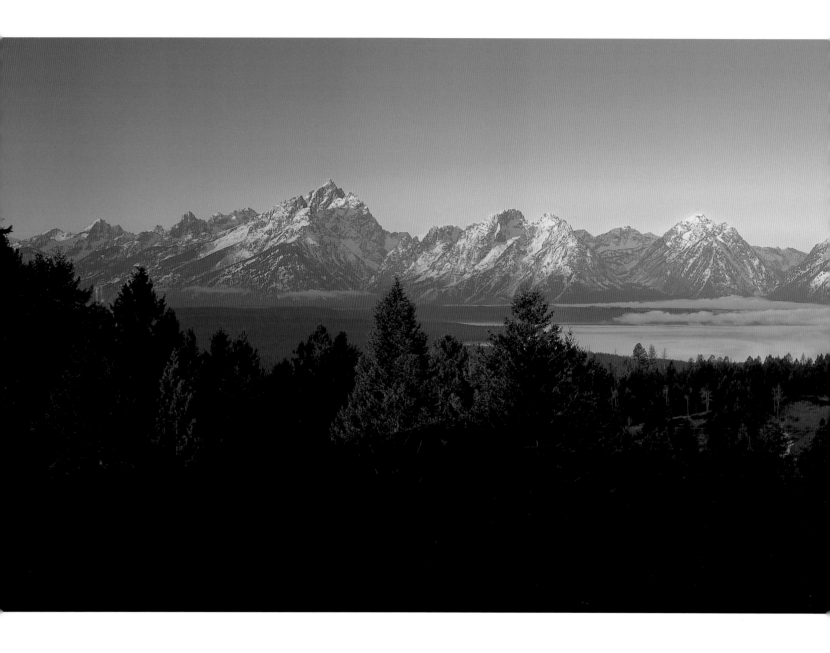

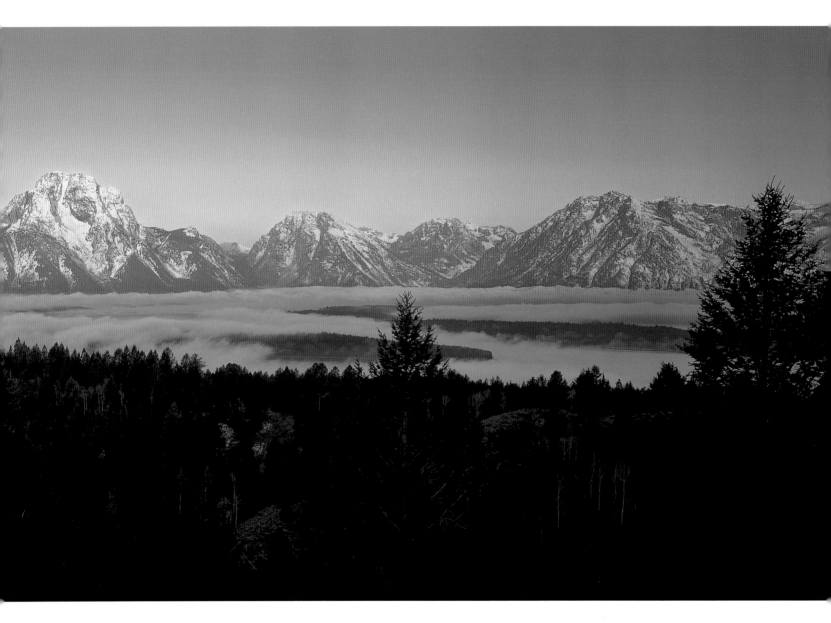

Tetons bathed in sunrise light above a foggy Jackson Lake, just after an October dusting of snow. HENRY H. HOLDSWORTH

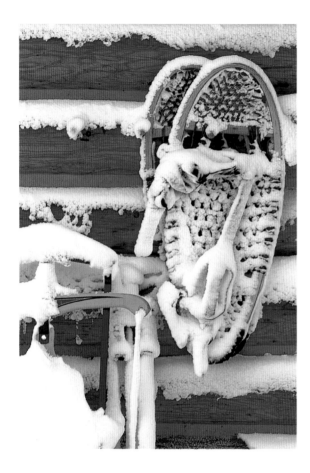

Above: No-fail forms of winter transportation.
HENRY H. HOLDSWORTH

Right: Rime-covered aspens. HENRY H. HOLDSWORTH

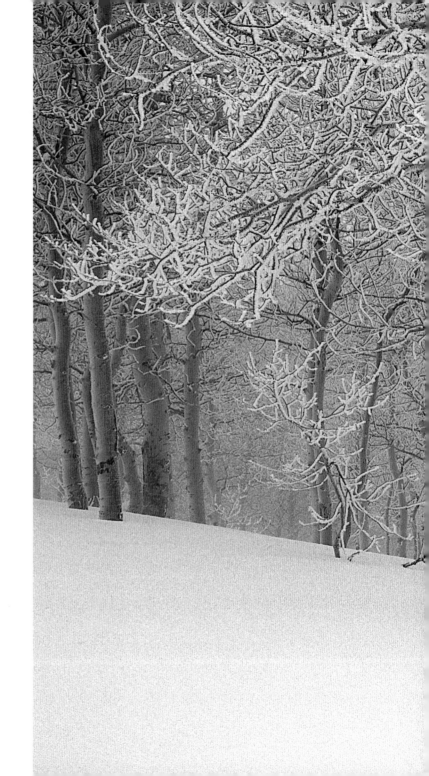

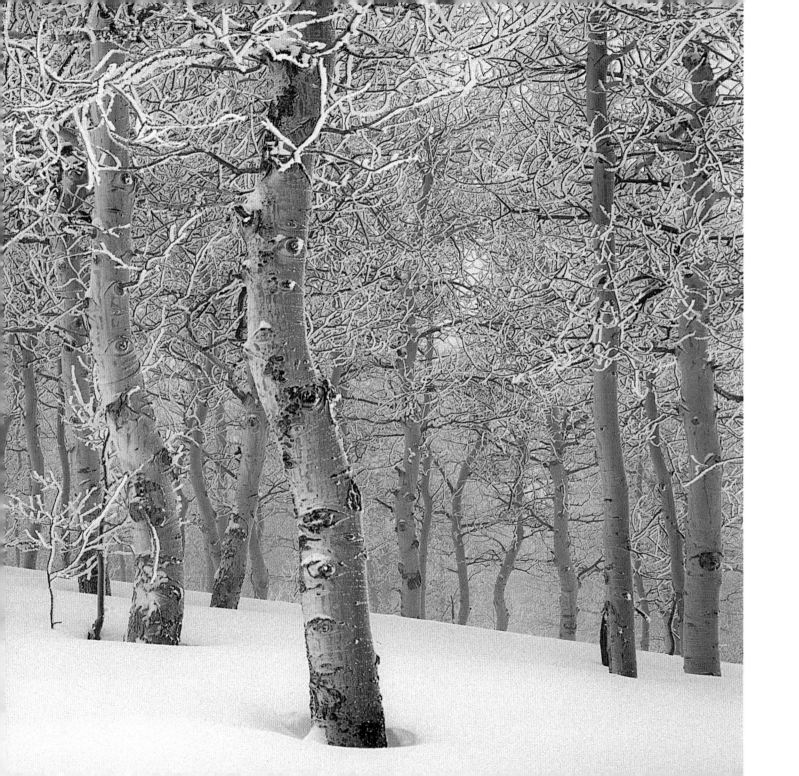

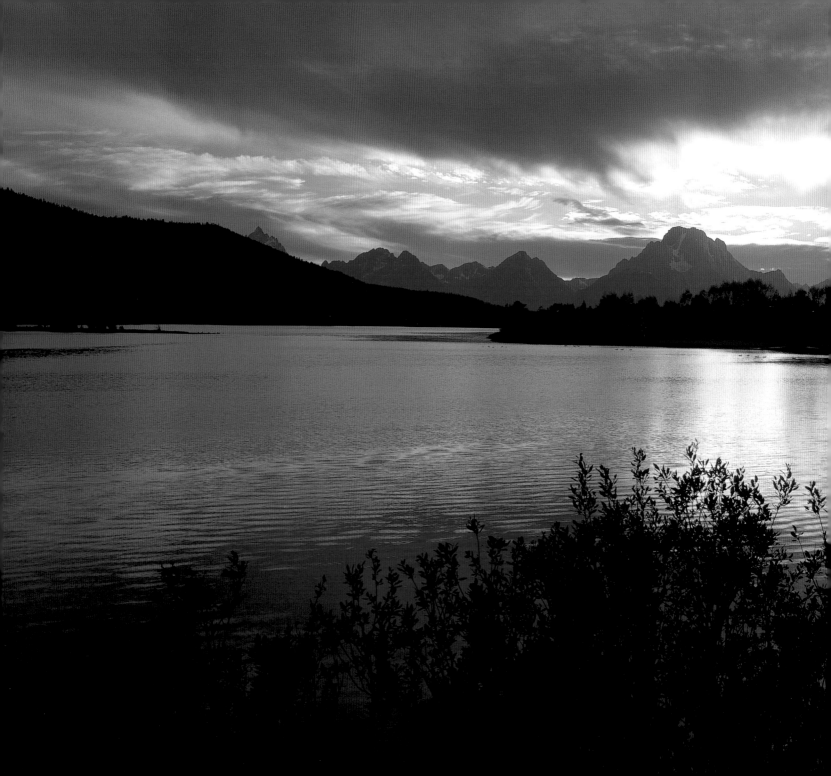

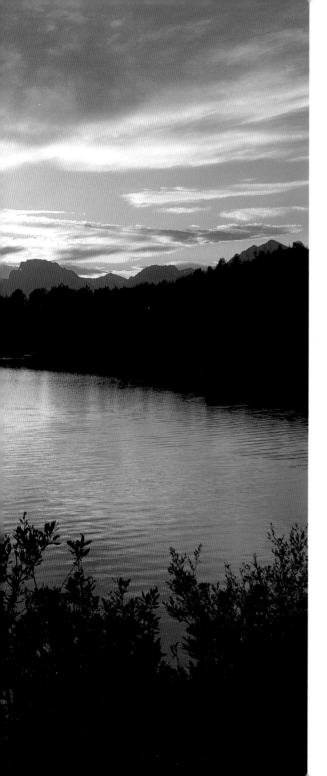

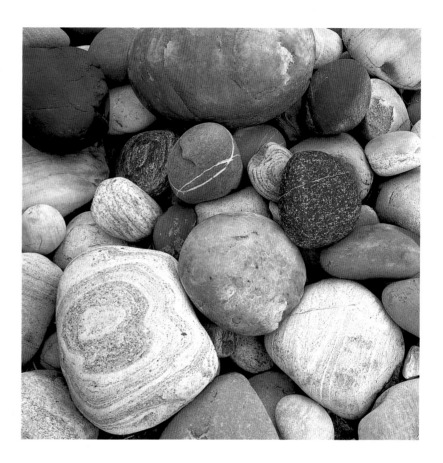

Above: River-polished rocks near Blacktail Ponds. FRED PFLUGHOFT

Left: Oxbow Bend sunset. FRED PFLUGHOFT

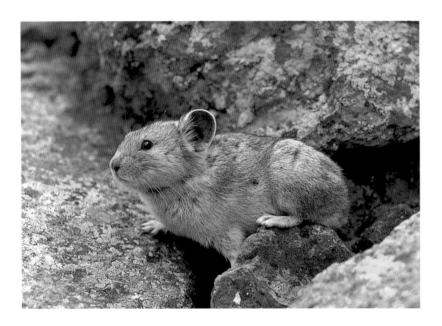

Above: Pikas spend their summers gathering grasses and making hay for winter dining. HENRY H. HOLDSWORTH

Right: The Cathedral view of the Tetons, near the String Lake turnoff. FRED PFLUGHOFT

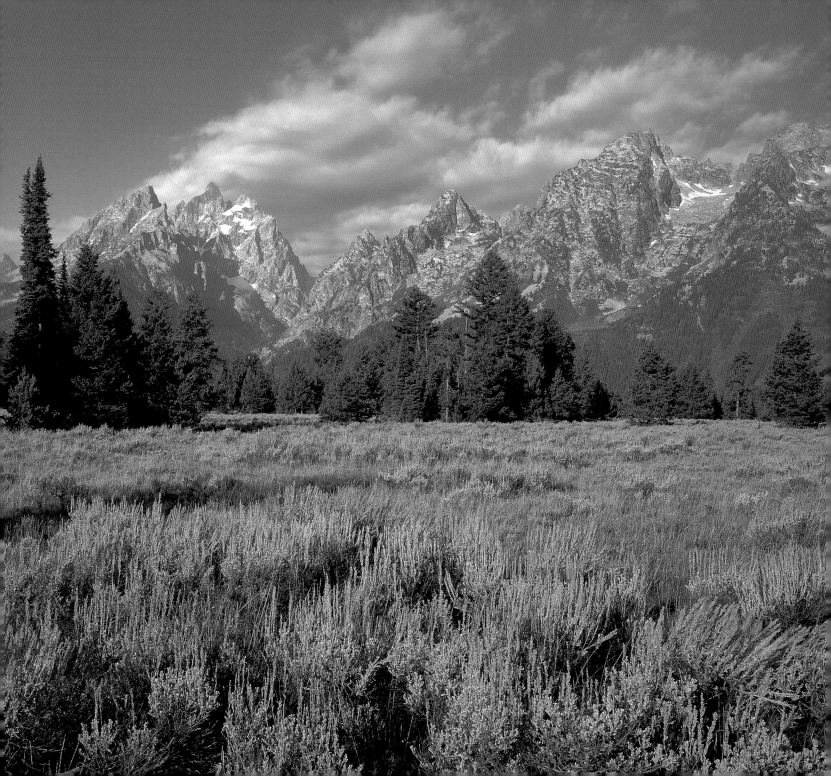

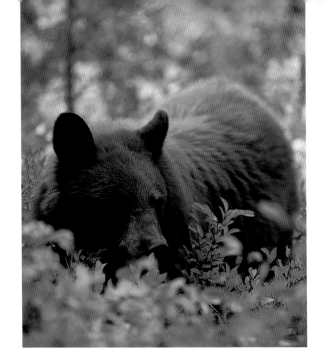

Left: A black bear eats autumn's crop of berries in preparation for winter sleep. HENRY H. HOLDSWORTH

Below: Colter Bay Marina on Jackson Lake. FRED PFLUGHOFT

Facing page: String Lake and the Tetons. FRED PFLUGHOFT

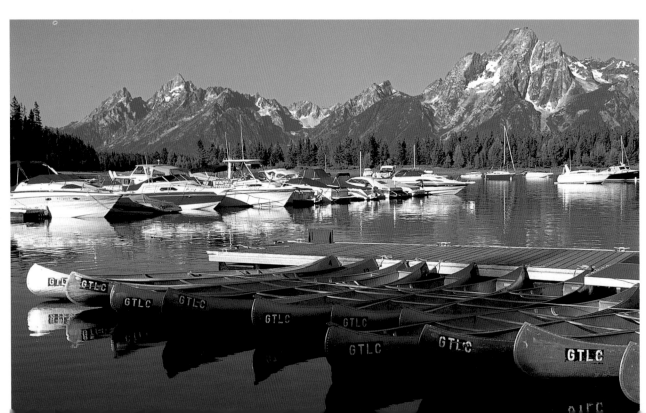

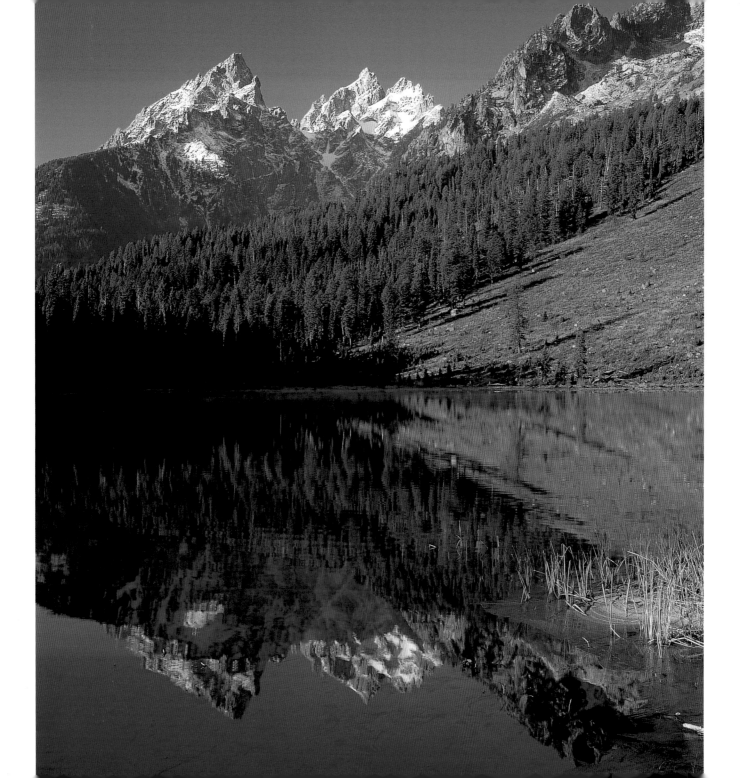

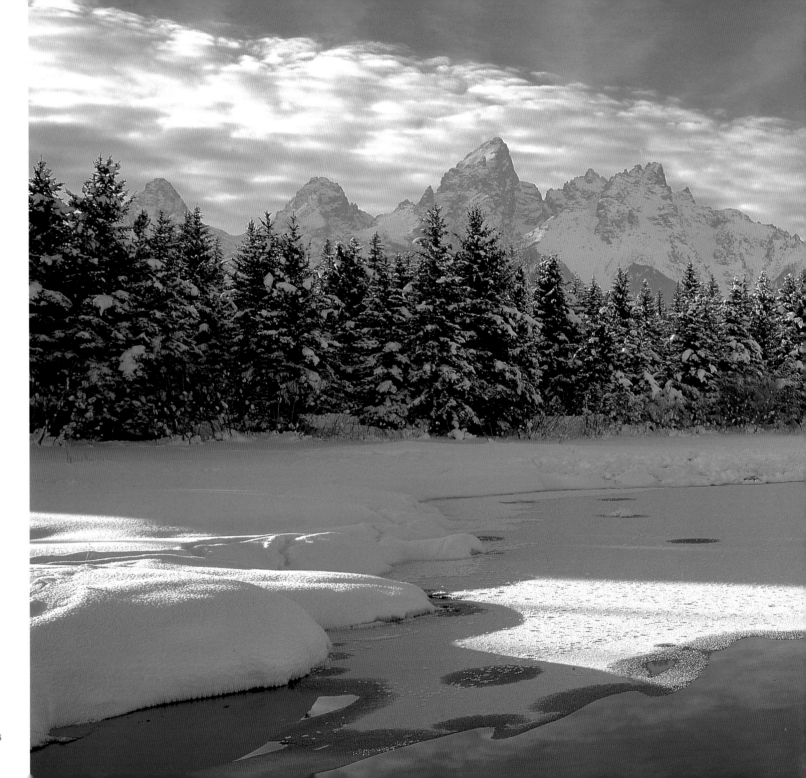

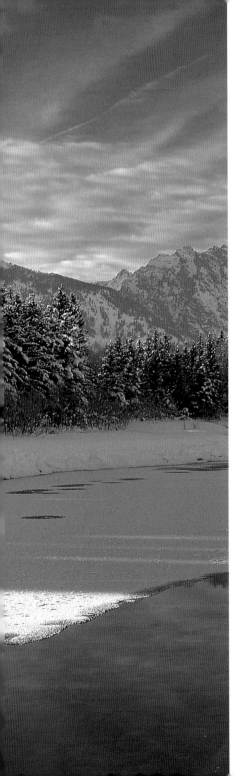

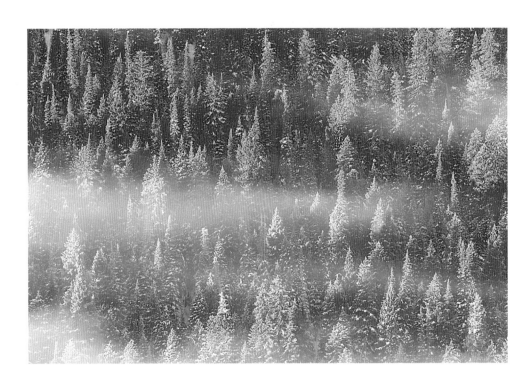

Above: Morning mist adds its tones to evergreens. HENRY H. HOLDSWORTH

Left: A glorious early snow storm. FRED PFLUGHOFT

Fred Pflughoft

Fred Pflughoft turned from watercolor painting to landscape photography in 1988. His full-color photography appears regularly in regional and national periodicals, on calendars and postcards from American and Canadian publishers, and is featured in the Farcountry Press books *Wyoming Wild and Beautiful, Oregon Wild and Beautiful, Yellowstone Wild and Beautiful, Grand Teton Wild and Beautiful, Wyoming Impressions,* and *Wyoming's Historic Forts.* He and his wife, Sue, have twin sons who join them in outdoor activities all year around.

Henry H. Holdsworth

Henry Holdsworth has spent two decades photographing Grand Teton and Yellowstone national parks, with an emphasis on wildlife. He has traveled to many remote and wild areas of the globe, but none is nearer to his heart that his own backyard around Jackson, Wyoming, where he lives with his family. Henry's works appear regularly in national periodicals, and was featured in *Wild and Beautiful Grand Teton National Park* (2000). He wrote and photographed the book *Yellowstone & Grand Teton Wildlife Portfolio* (2001).